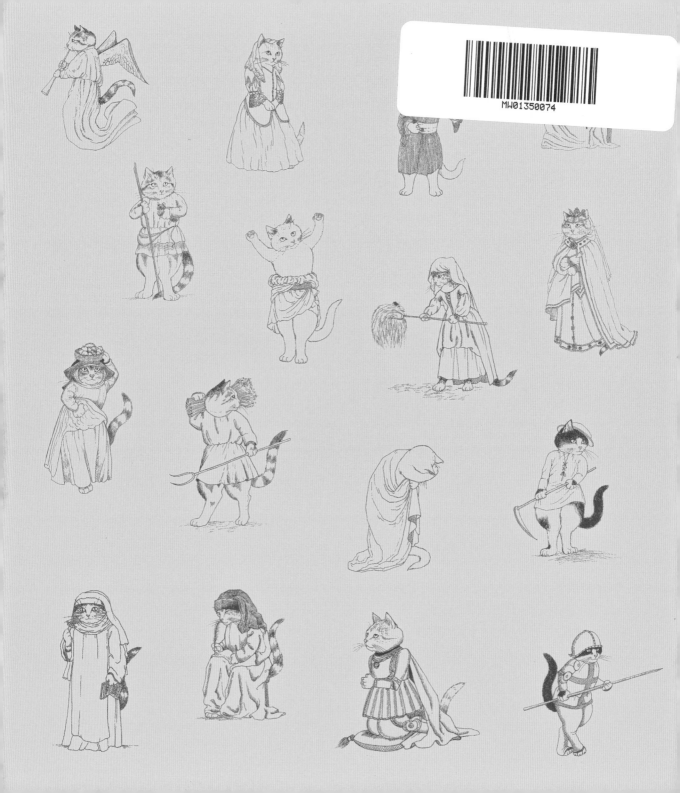

CATS GALORE ENCORE!

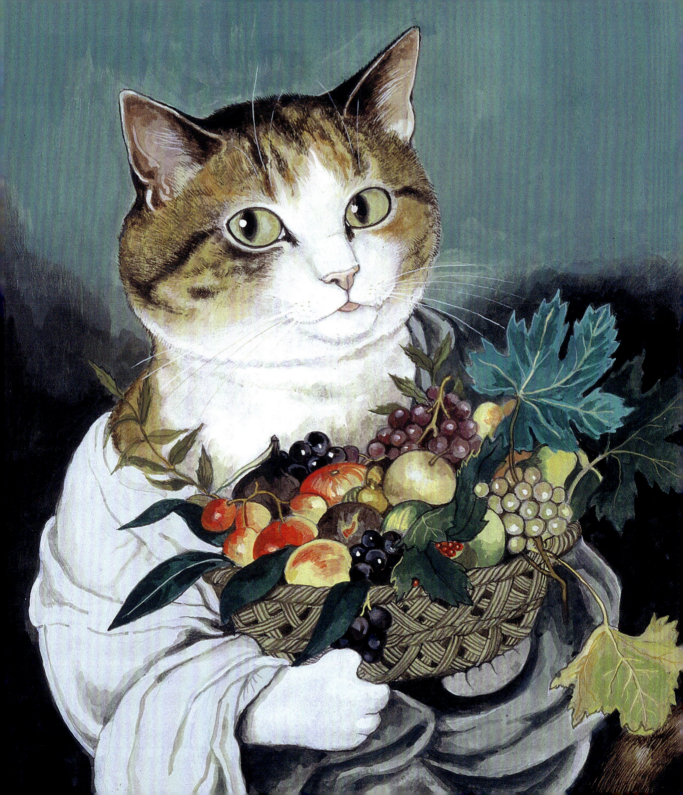

SUSAN HERBERT

CATS GALORE ENCORE!

A New Compendium of Cultured Cats

This book is dedicated to the memory of Susan Herbert (1945–2014), and to Polly, Clover, and all of the cats who inspired her work.

On p. 2: Caravaggio, *Boy with a Basket of Fruit*, 1593–5

Cats Galore Encore!: A New Compendium of Cultured Cats
© 2021 Thames & Hudson Ltd, London
Illustrations © 2021 The Estate of Susan Herbert

All Rights Reserved. No part of this publication may be reproduced or transmitted in any form or by any means, electronic or mechanical, including photocopy, recording or any other information storage and retrieval system, without prior permission in writing from the publisher.

First published in 2021 in the United States of America by
Thames & Hudson Inc., 500 Fifth Avenue, New York, New York 10110

Library of Congress Control Number 2021932162

ISBN 978-0-500-02465-2

Printed and bound in China by C & C Offset Printing Co. Ltd

Be the first to know about our new releases,
exclusive content and author events by visiting
thamesandhudson.com
thamesandhudsonusa.com
thamesandhudson.com.au

Contents

Preface
by Janet Froud

6

Introduction

8

The Paintings

11

Preface
by Janet Froud

Susan Herbert was my younger sister, born in the Warwickshire village of Hampton-in-Arden in 1945. We were very close all our lives. Drawing was a large part of our childhood – our architect father encouraged us by providing old plans to draw on, and we invented stories and characters, making cardboard 'cut-outs' to act them out. Early artistic influences were Beatrix Potter and Arthur Rackham.

In the early 1960s we were obsessed with Shakespeare – no Beatlemania for us – and spent our Saturdays at the theatre in nearby Stratford-upon-Avon. Later on, we both worked for the RSC until I married and Susan decamped to London to pursue her new enthusiasm for opera, triggered by Gilbert and Sullivan. A job at the English National Opera followed. She continued painting animals in various guises, mostly mice and rats, changing these to cats when she realized they had more general appeal. Her 'Rodent Ring Cycle' was published in *Opera* magazine; Wagner was a particular favourite.

After a term at the Ruskin School of Art, Susan decided that student life was not for her and removed to Bath and the Theatre Royal. Other jobs followed as she tried to gain recognition for her art, with little success. Then Stanley Baron at Thames & Hudson saw its possibilities, and *The Cats Gallery of Art*, the first of many books, was published in 1990. Susan's work was very popular in Japan, and two exhibitions of her paintings were held in Tokyo.

Susan's aim was always to amuse and entertain, and she coped with occasional charges of artistic heresy. Her later years were enlivened by her cats Polly, who appeared in many of her paintings (and is seen opposite, as Penelophon), and later Clover, and her obsession with *The Lord of the Rings*, the tenor Jonas Kaufmann and collecting soft toys. My children admired her for her 'bohemian' lifestyle, ribald humour and capacity for red wine. Susan bore the ups and downs of her cancer treatment with great courage and a lot of laughter. She died just short of her 69th birthday in 2014.

OPPOSITE Edward Burne-Jones, *King Cophetua and the Beggar Maid*, 1884

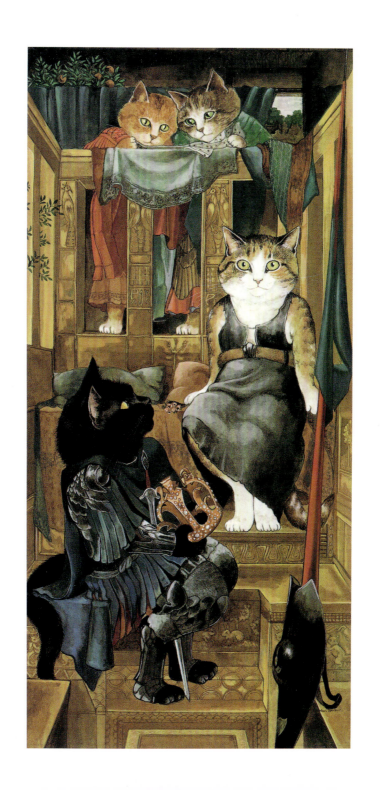

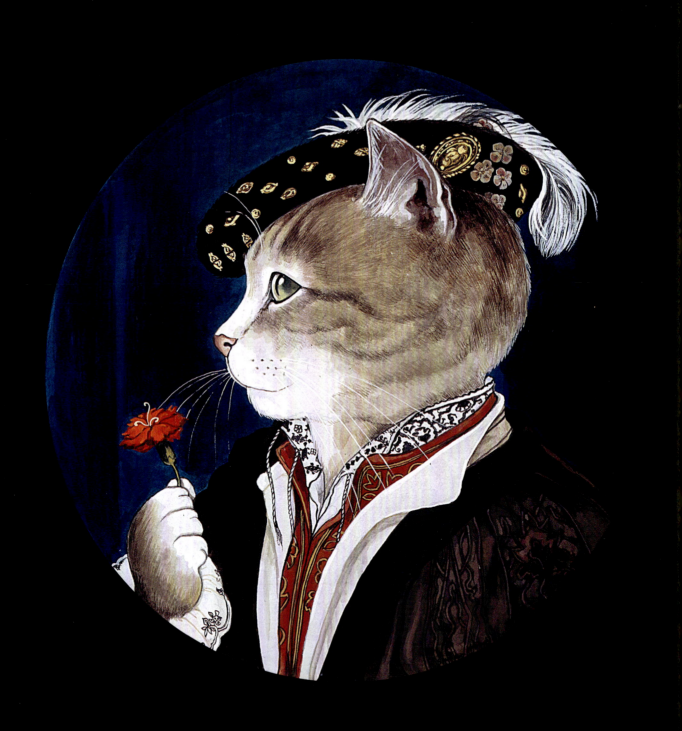

Introduction

Whiskered faces peer from beneath beribboned bonnets; furry tails hang over arms like parasols or stretch upwards to brush against a row of medals; soft, fat paws grapple with flowers, hats and pieces of fruit. There are damsels in distress, Old Testament prophets, even the odd tortured artist, post-ear slicing. From the Middle Ages to the Impressionists, this is the wonderfully charming world of Susan Herbert.

In this second helping of cats in art, felines take over yet more of the world's best-loved masterpieces. They crowd into the pages of the 15th-century *Très Riches Heures*, zoom through the air as cherubic blindfolded Cupids in Renaissance masterworks and pose stiffly in royal portraits, before loosening things up in the 19th century as artists take paint and palette out into the countryside.

These aren't just slavish reproductions of well-known works of art, however, with the characters replaced by cats. In Herbert's hands, the cats *are* the characters, stepping into the paintings to assume the role of the Virgin Mary, the King of France or God himself, with more than one pair of pointy ears offering structural support to a crown or garland of flowers – often above that look of grumpy resignation so familiar to cat-parents everywhere.

Herbert's own plumptious tabby Polly pops up throughout this book, giving some impressive side eye as Hans Holbein's *Simon George of Cornwall* (opposite), sticking out a mischievous tongue in Caravaggio's *Boy with a Basket of Fruit* (p. 2) and perching prettily in Dante Gabriel Rossetti's *The Day Dream* (p. 181), to name but a few. But Polly wasn't the only star in the family – Clover, a white cat with a tabby patch between her ears, also made an appearance in Herbert's paintings, most notably in her ballet series.

The essential feline natures of Polly, Clover and all of Herbert's cats shine from every page, imbuing her work with warmth and humour and ensuring this beloved artist her legions of devoted fans.

OPPOSITE Hans Holbein, *Portrait of Simon George of Cornwall*, 1535–40

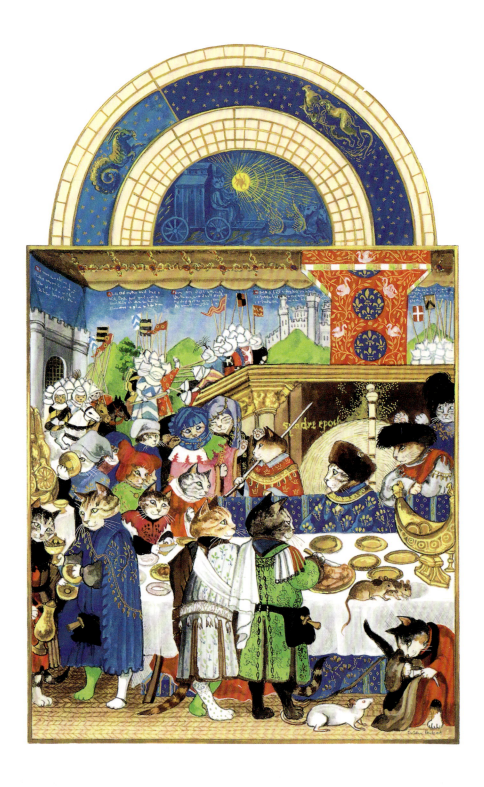

Limbourg Brothers
January, from *Très Riches Heures du Duc de Berry*
c. 1412–16

OVERLEAF, LEFT Limbourg Brothers, *May*, *c.* 1412–16
OVERLEAF, RIGHT Limbourg Brothers, *August*, *c.* 1412–16

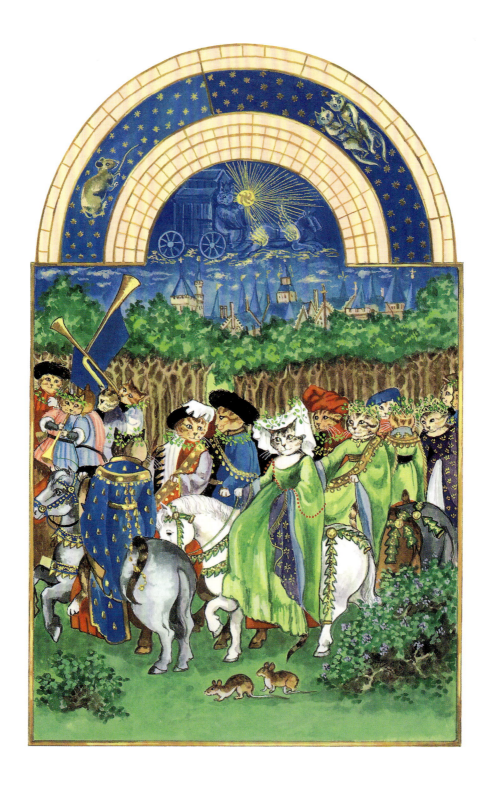

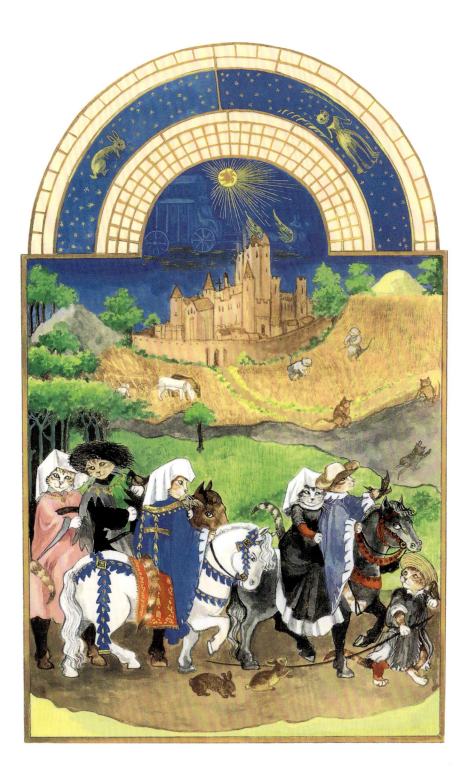

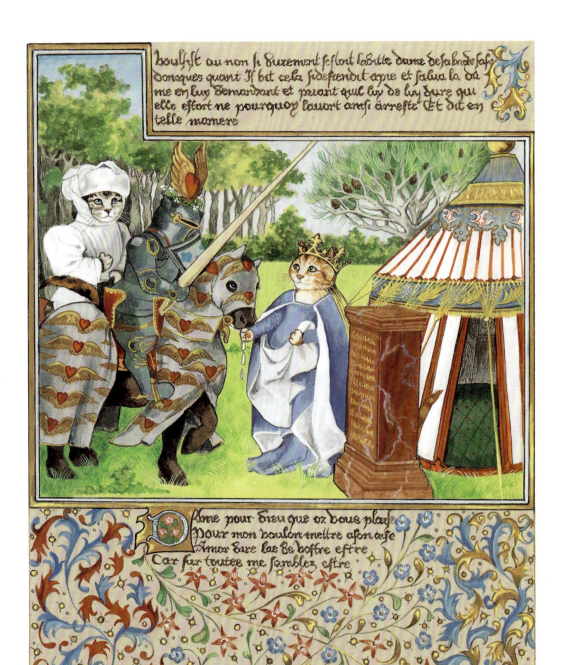

ABOVE Barthélemy d'Eyck, *King René's Book of Love*,
folios 31 (left) and 51 (right), 1457

OPPOSITE Barthélemy d'Eyck, *King René's Book of Love*, folio 5, 1457

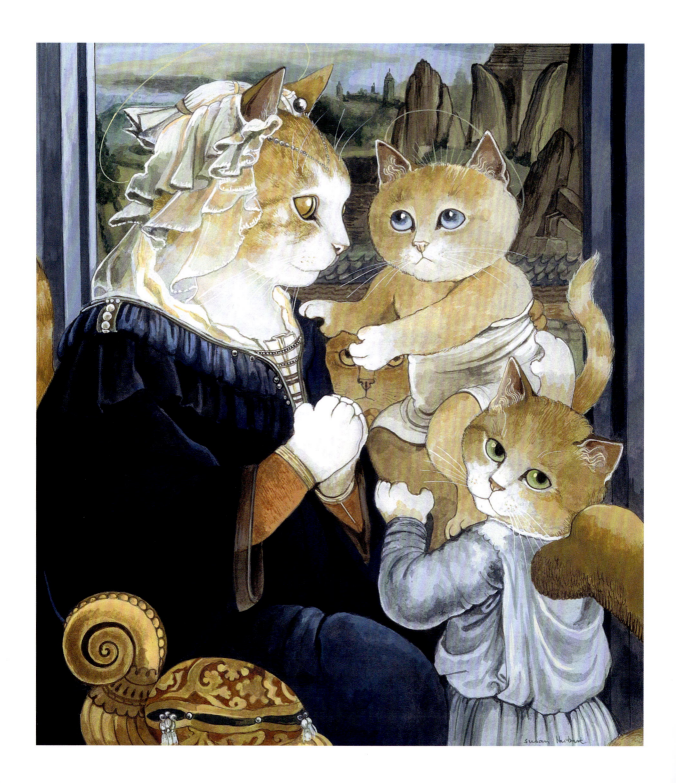

Fra Filippo Lippi
Madonna and Child with Two Angels
c. 1460–5

Sandro Botticelli
Primavera
c. 1480

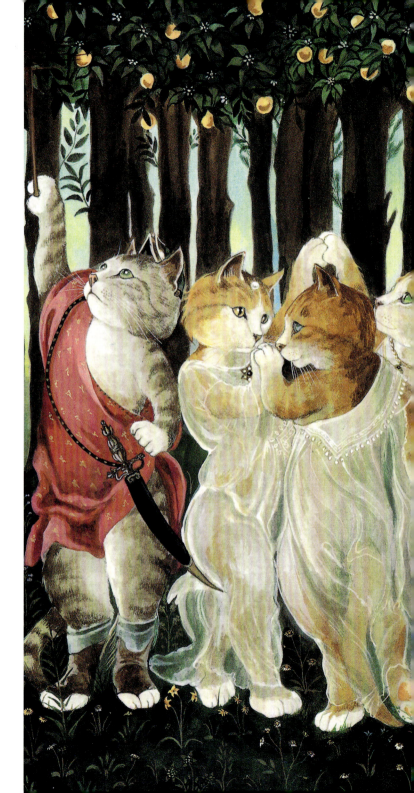

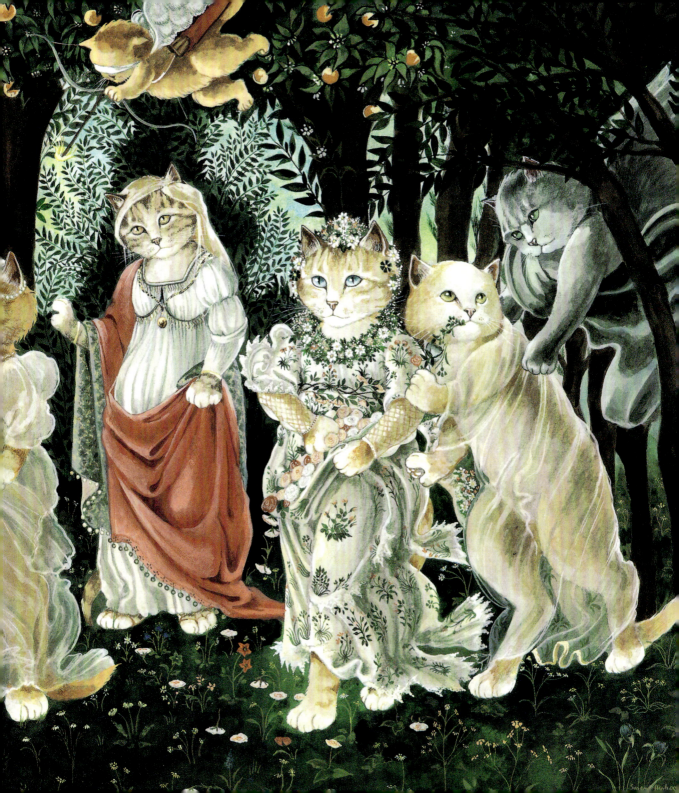

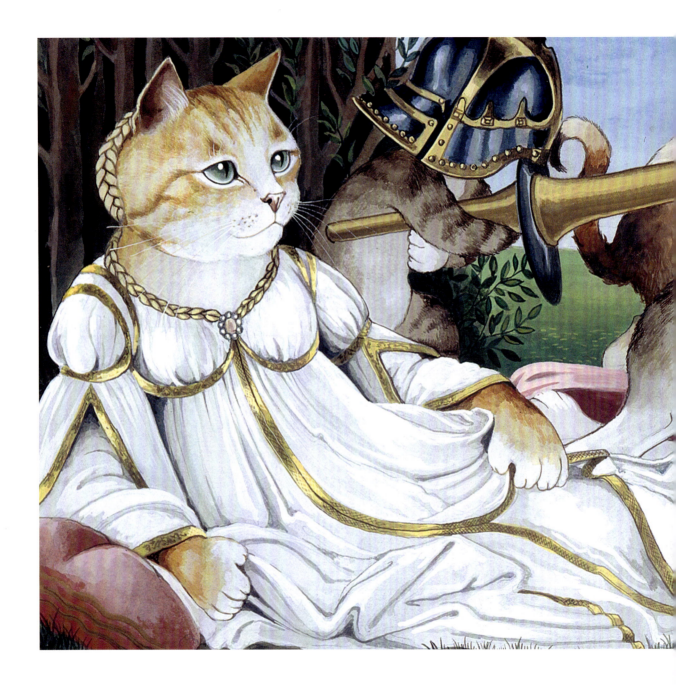

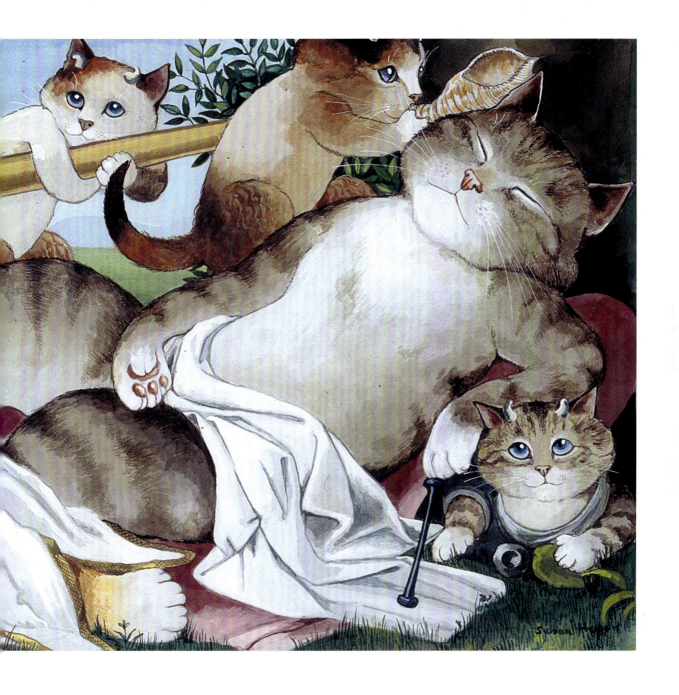

Sandro Botticelli, *Venus and Mars*, c. 1485

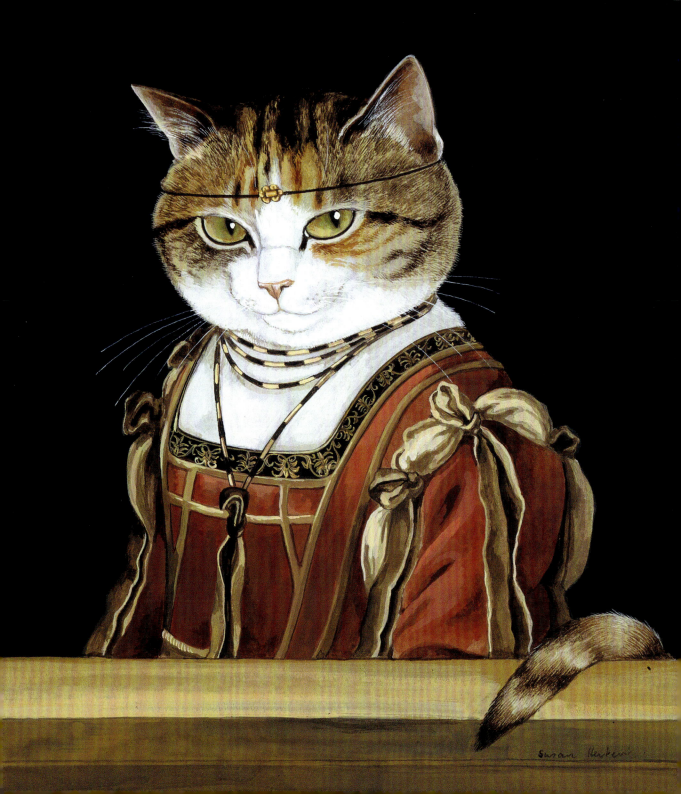

Leonardo da Vinci
La Belle Ferronnière
1495–9

Leonardo da Vinci
Virgin of the Rocks
c. 1491/2–9 and 1506–8

OVERLEAF Follower of Filippino Lippi,
The Worship of the Egyptian Bull God, Apis, c. 1500

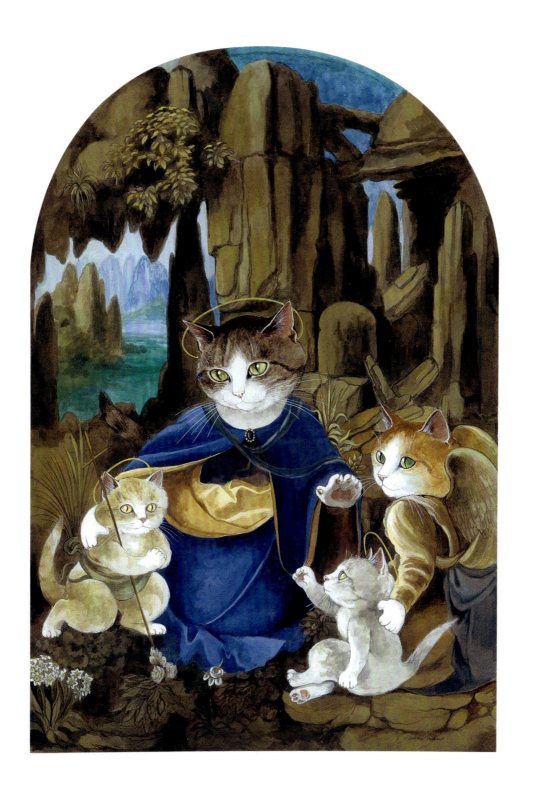

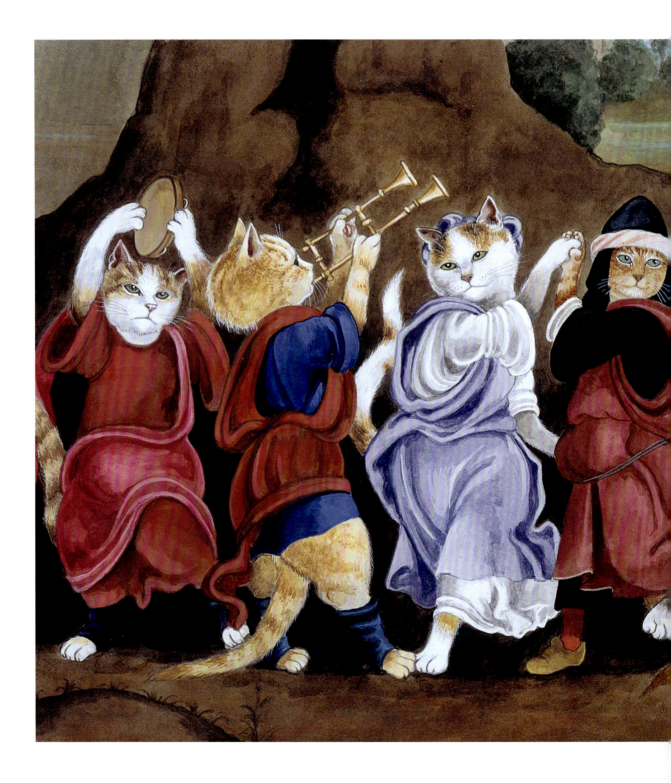

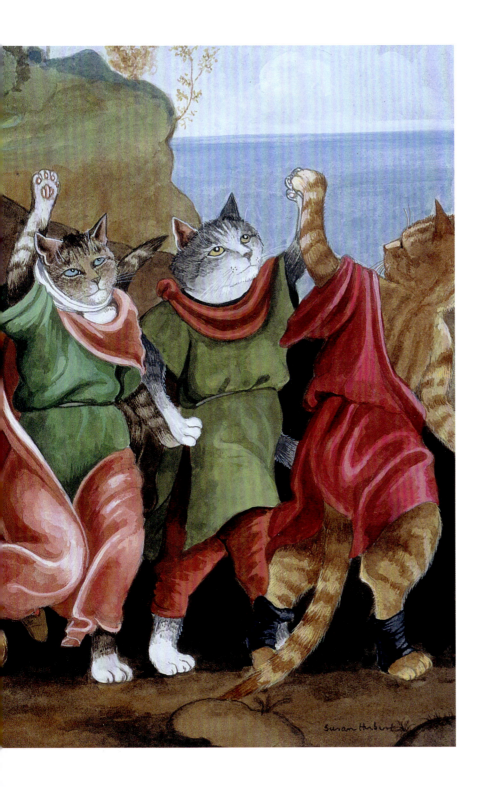

Giovanni Bellini
Portrait of Doge Leonardo Loredan
c. 1501–2

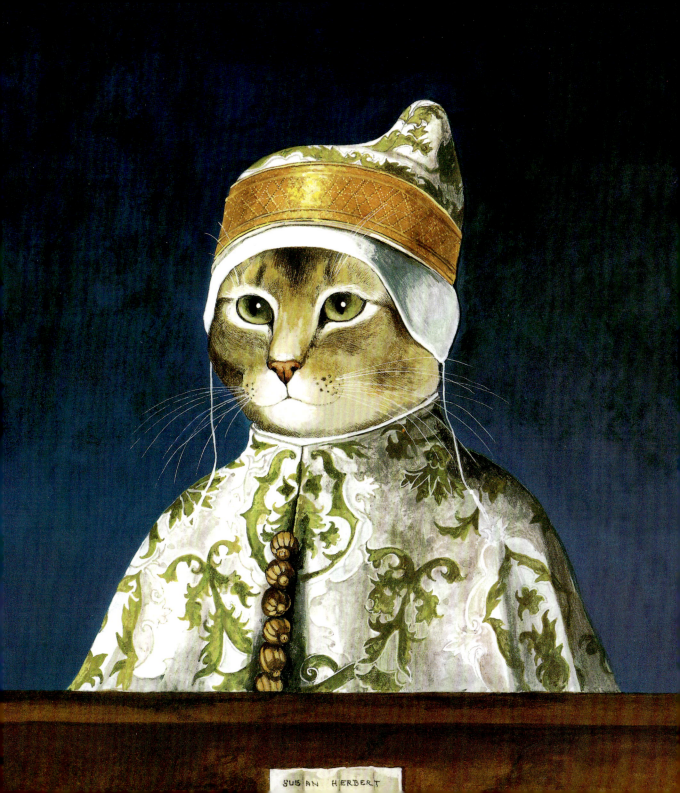

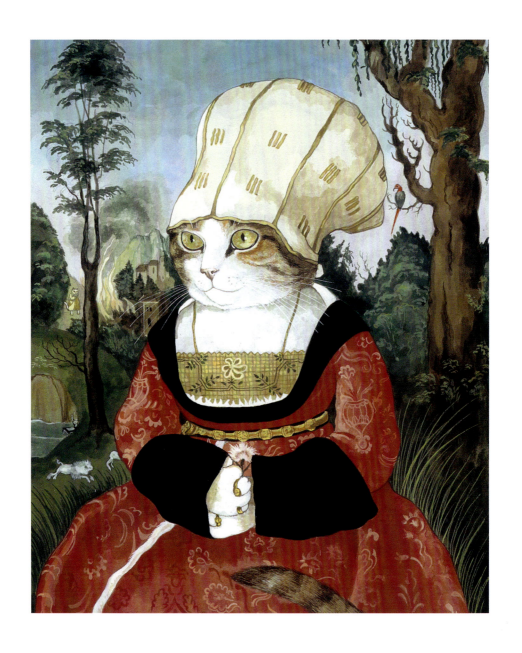

Lucas Cranach the Elder, *Portrait of Anna Putsch*, 1502

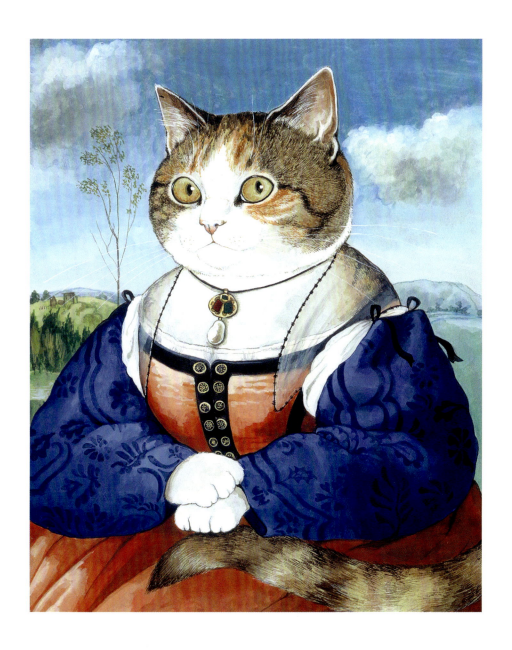

Raphael, *Portrait of Maddalena Doni*, c. 1504–7

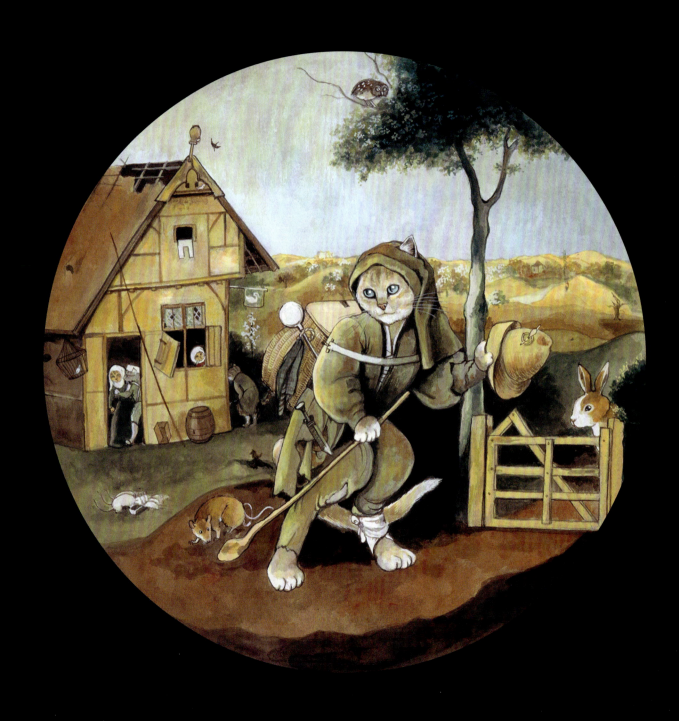

Hieronymus Bosch
The Wayfarer
c. 1500

Michelangelo
The Doni Tondo
1505–6

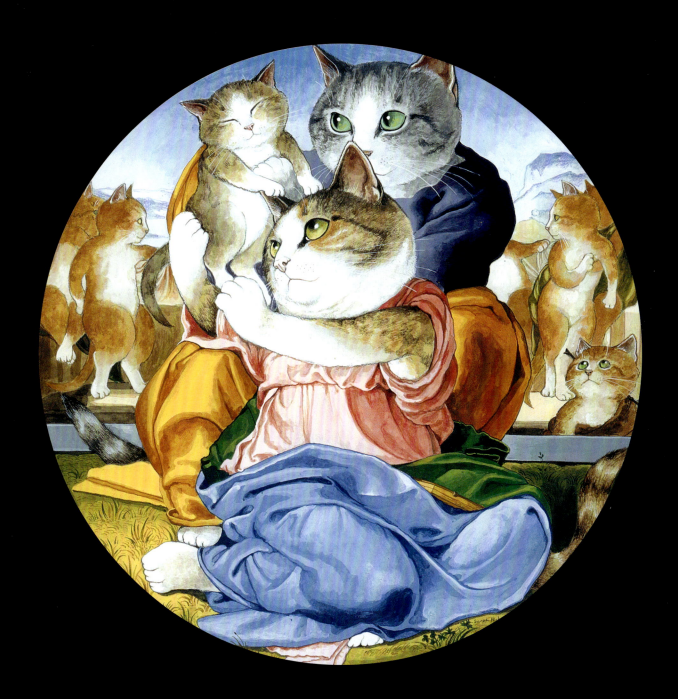

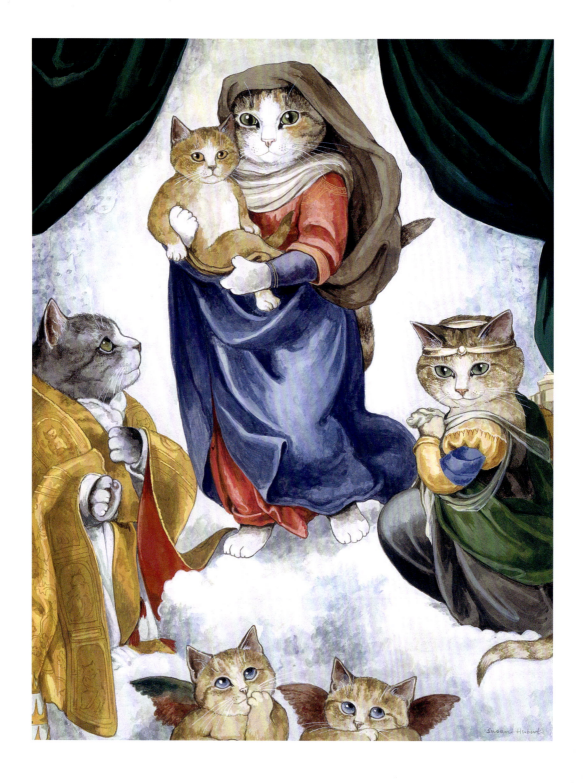

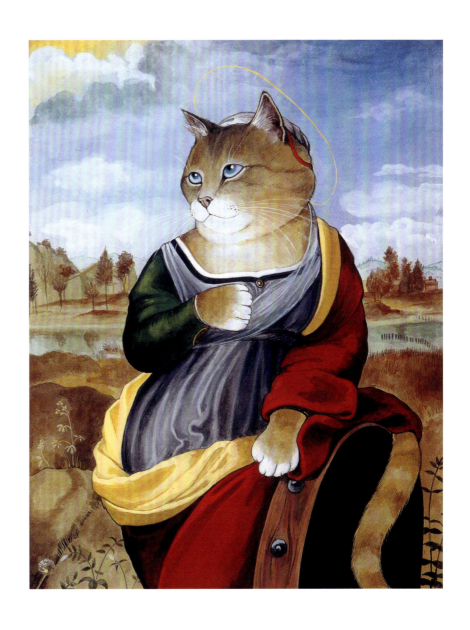

ABOVE Raphael, *St Catherine of Alexandria*, c. 1507

OPPOSITE Raphael, *The Sistine Madonna*, 1512

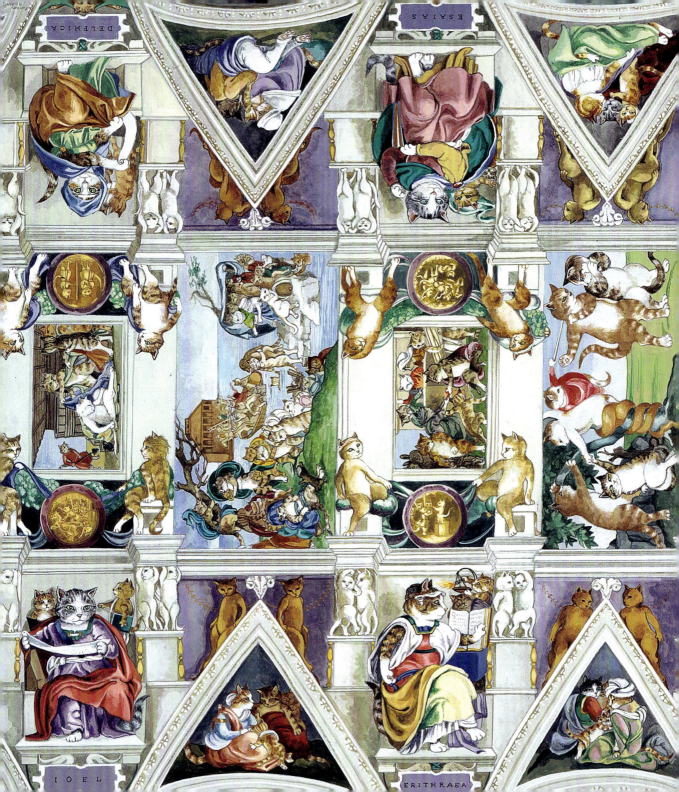

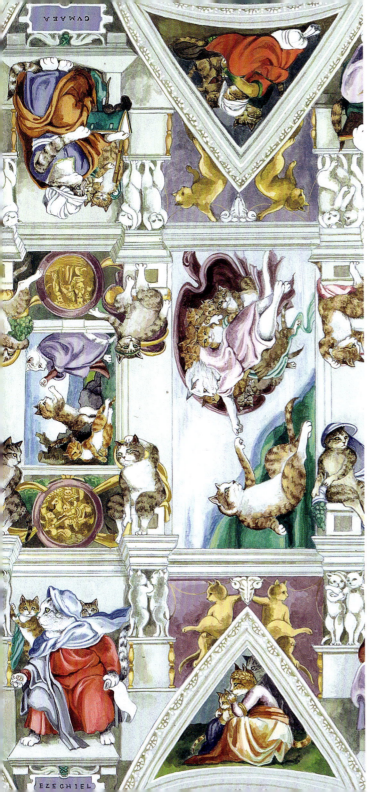

Michelangelo
Sistine Chapel ceiling
1508–12

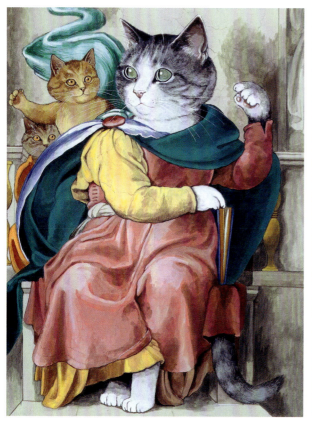
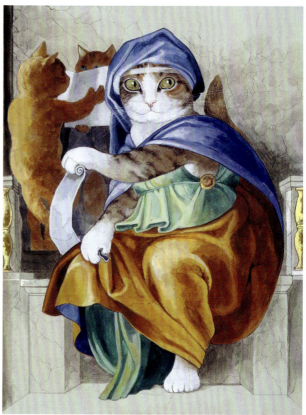

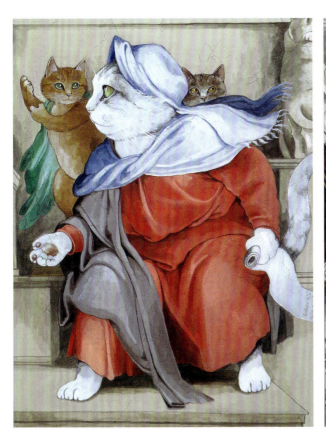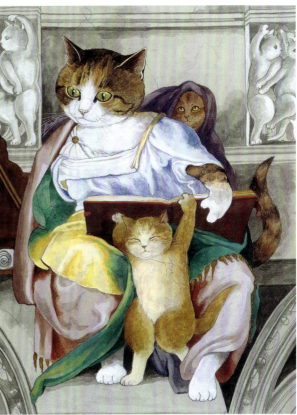

ABOVE Michelangelo, *Ezekiel* (left) and *Daniel* (right), from the Sistine Chapel ceiling, 1508–12

OPPOSITE Michelangelo, *Isaiah* (left) and *Delphic Sibyl* (right), 1508–12

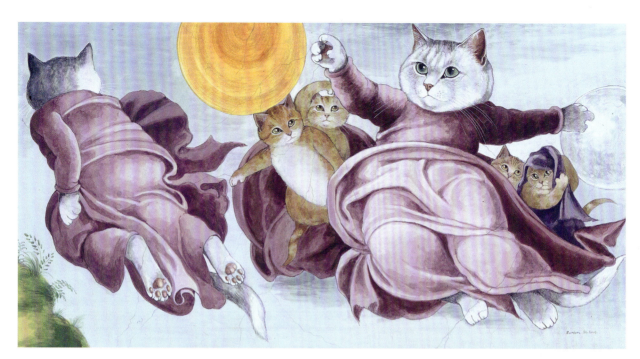
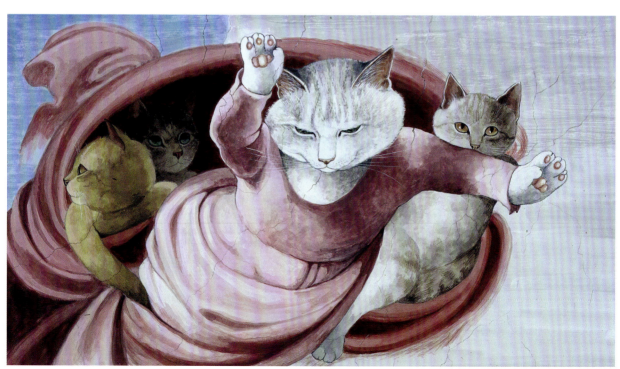

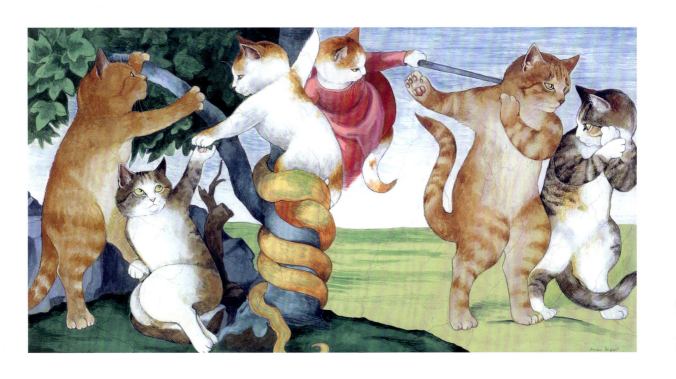

ABOVE Michelangelo, *Temptation and expulsion from Eden*, from the Sistine Chapel ceiling, 1508–12

OPPOSITE Michelangelo, *Creation of the sun, moon and planets* (above) and *God dividing the waters* (below), 1508–12

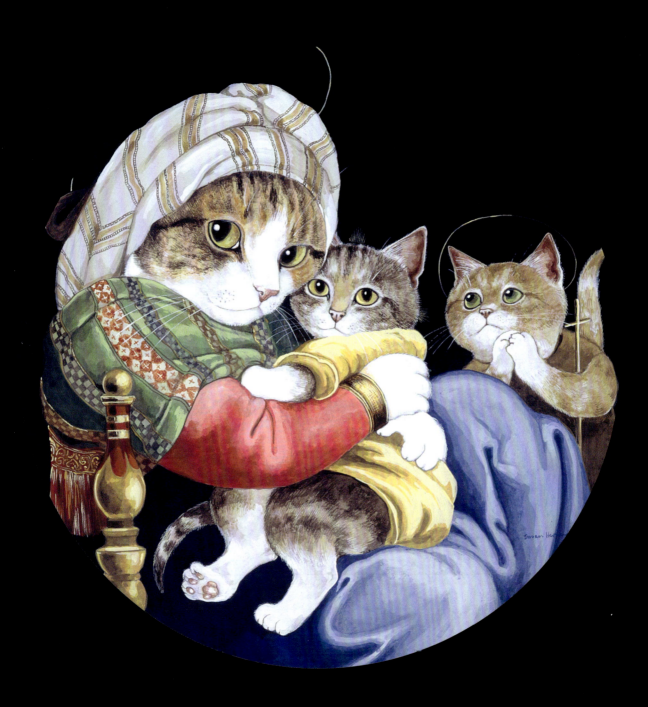

Raphael
Madonna della Sedia
c. 1513–14

Raphael
The Triumph of Galatea
c. 1514

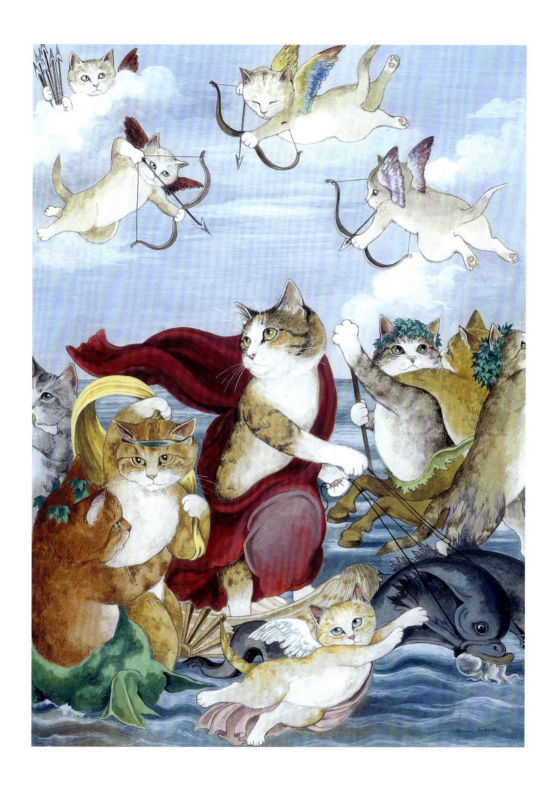

Titian
Flora
c. 1517

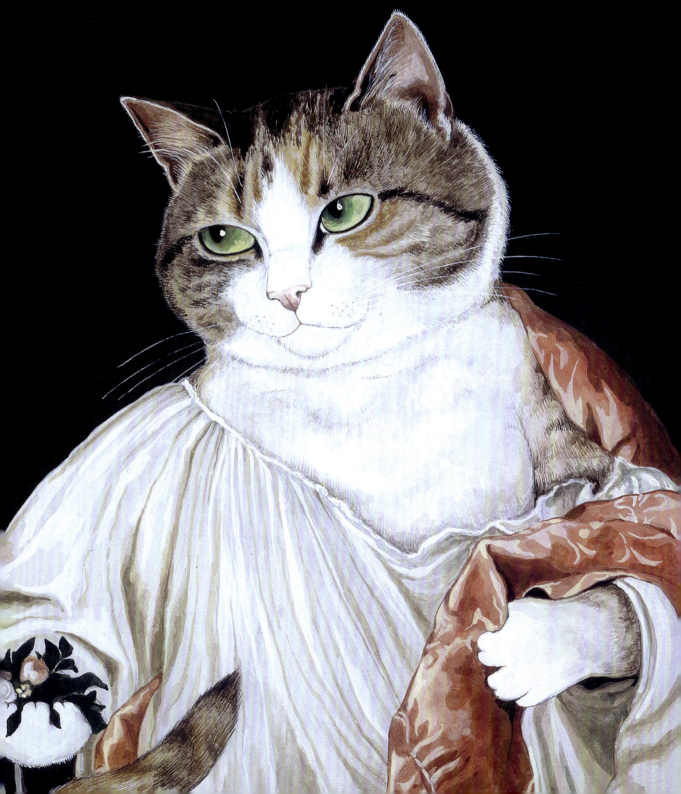

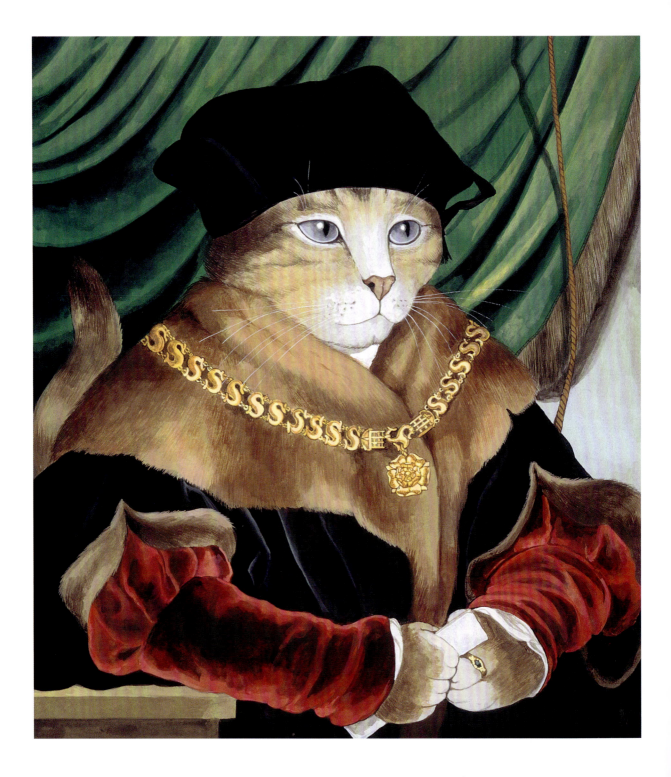

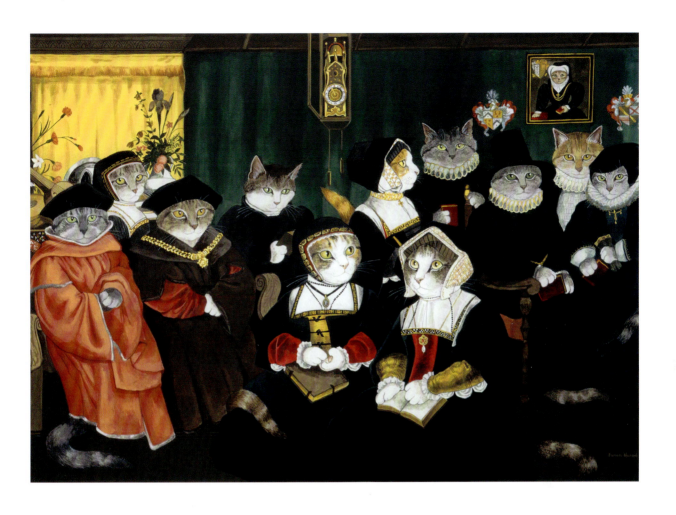

ABOVE Rowland Lockey, *Sir Thomas More with his Family and Household*, after a lost original by Hans Holbein, *c.* 1527–8

OPPOSITE Hans Holbein, *Sir Thomas More*, 1527

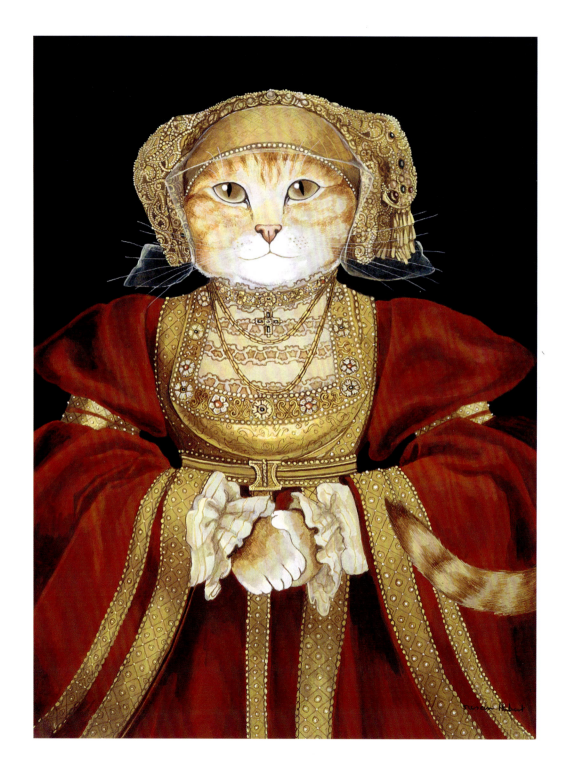

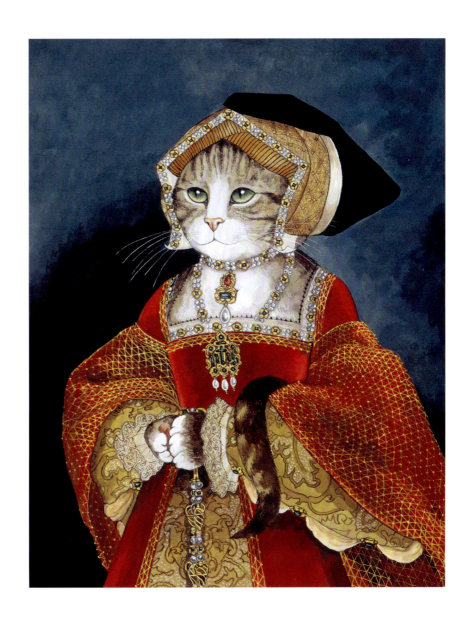

ABOVE Hans Holbein, *Jane Seymour*, 1536

OPPOSITE Hans Holbein, *Anne of Cleves*, 1539

Agnolo Bronzino
Lucrezia Panciatichi
c. 1540

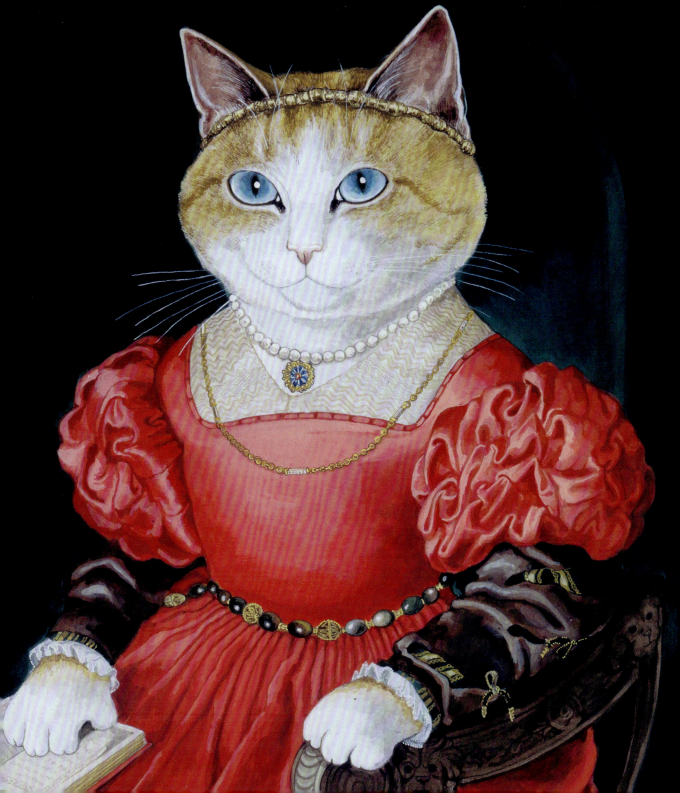

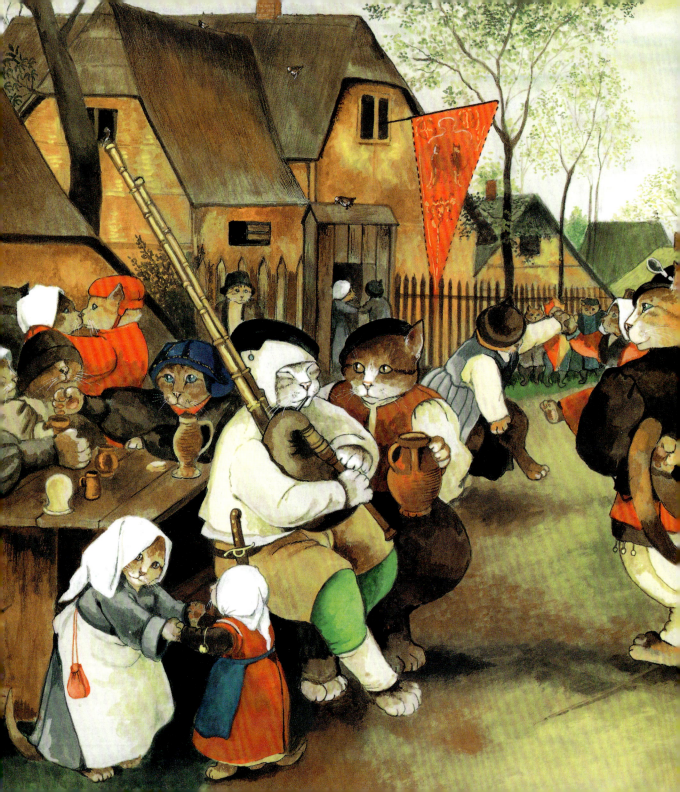

Pieter Bruegel the Elder
The Peasant Dance
c. 1568

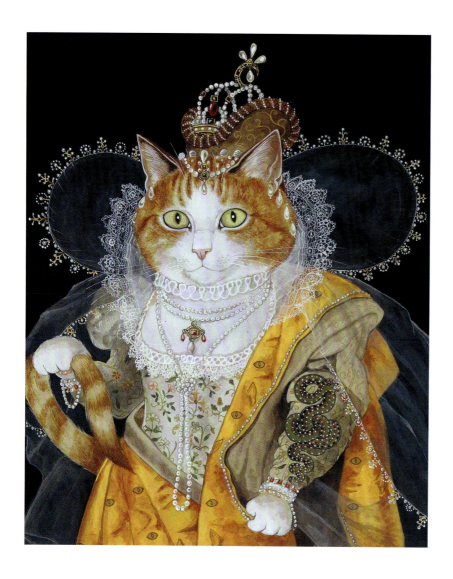

ABOVE Marcus Gheeraerts the Younger or Isaac Oliver
Elizabeth I (The Rainbow Portrait), c. 1600–2

OPPOSITE Marcus Gheeraerts the Younger
Elizabeth I (The Ditchley Portrait), c. 1592

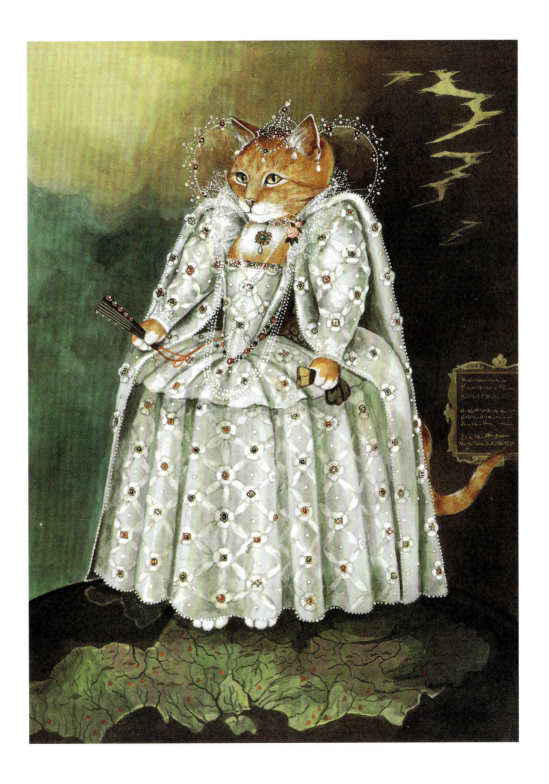

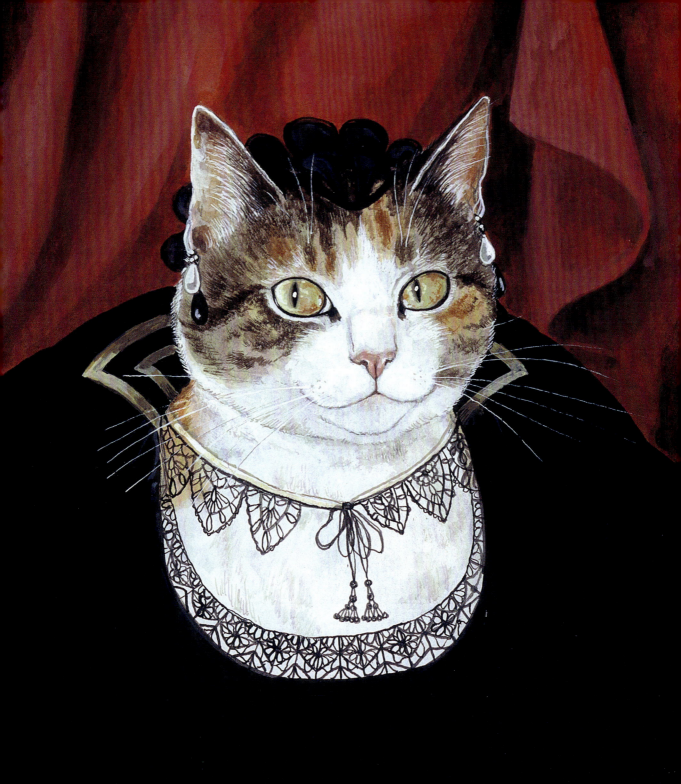

Unknown artist
Anne of Denmark
c. 1612

Peter Paul Rubens
The Honeysuckle Bower
c. 1609

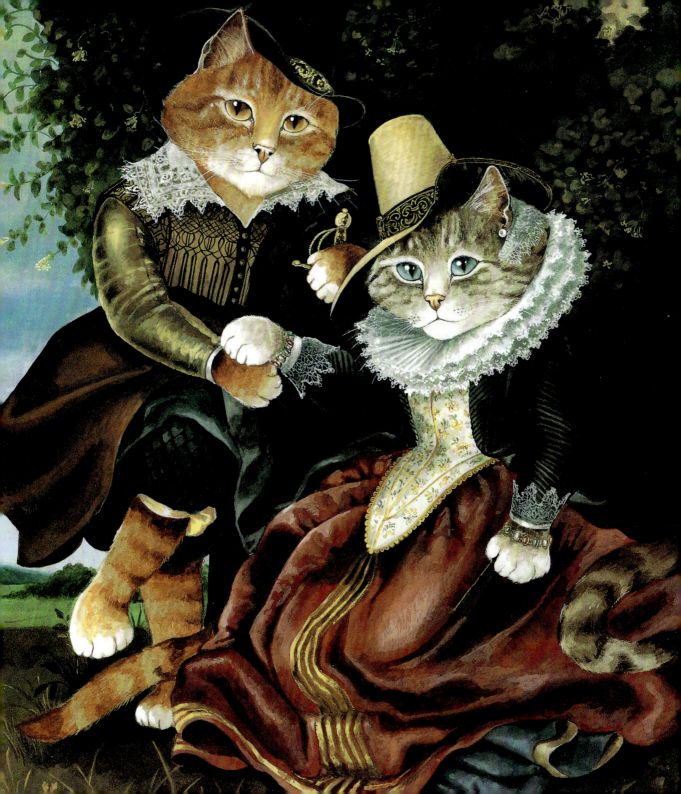

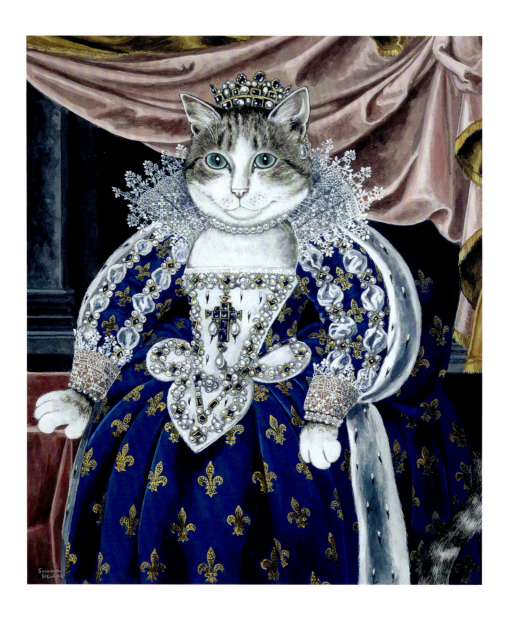

ABOVE Frans Pourbus the Younger, *Marie de' Medici*, 1613

OPPOSITE Peter Paul Rubens, *Portrait of Susanna Lunden*, c. 1622–5

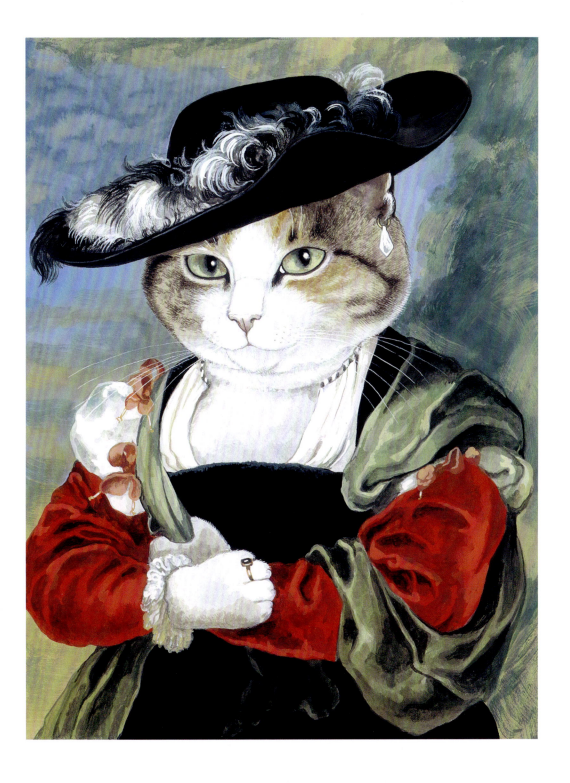

Rembrandt van Rijn
Saskia van Uylenburgh in Arcadian Costume
1634

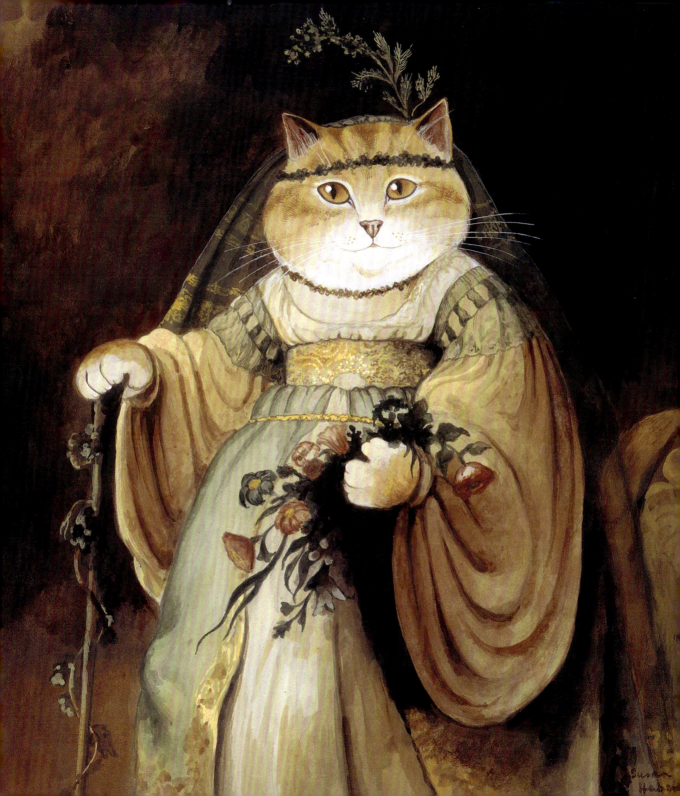

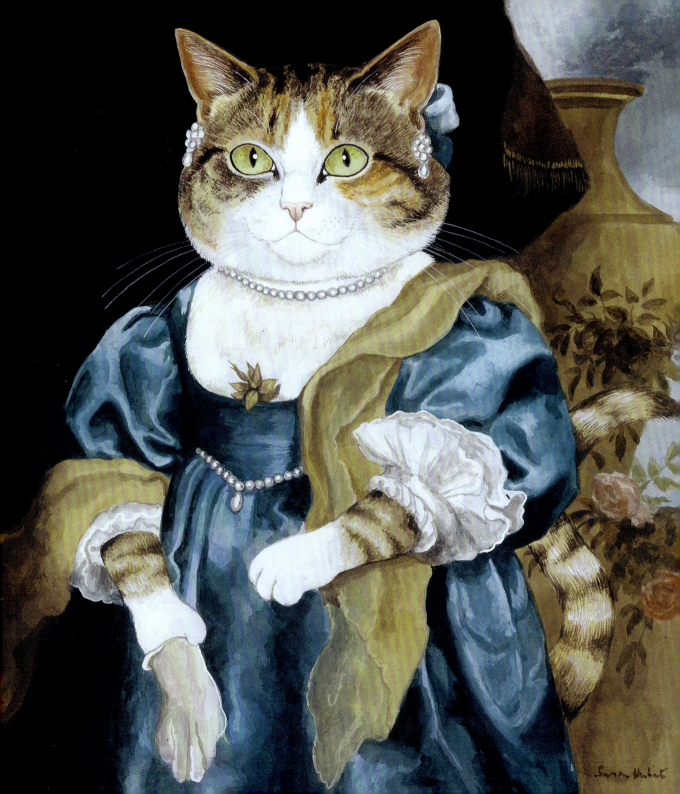

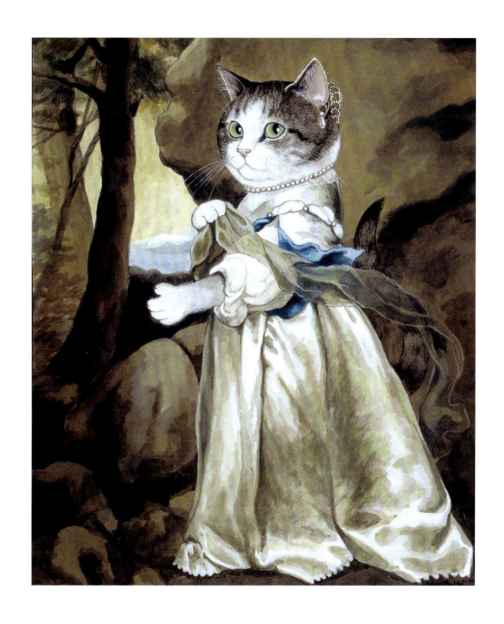

ABOVE Anthony van Dyck, *Lady Frances Cranfield, c.* 1637

OPPOSITE Anthony van Dyck, *Lady Anne Carr,* 1638

Rembrandt van Rijn
The Night Watch
1642

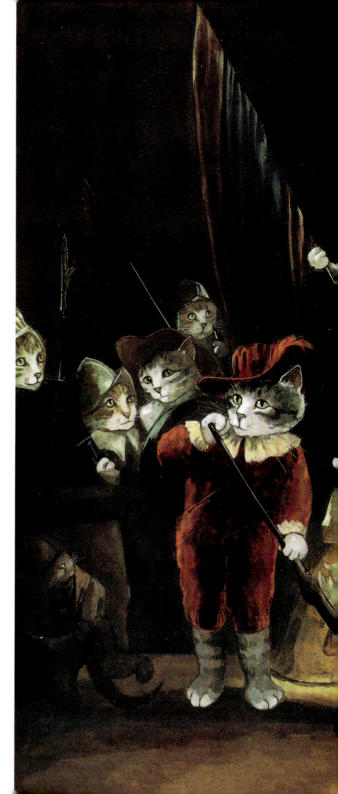

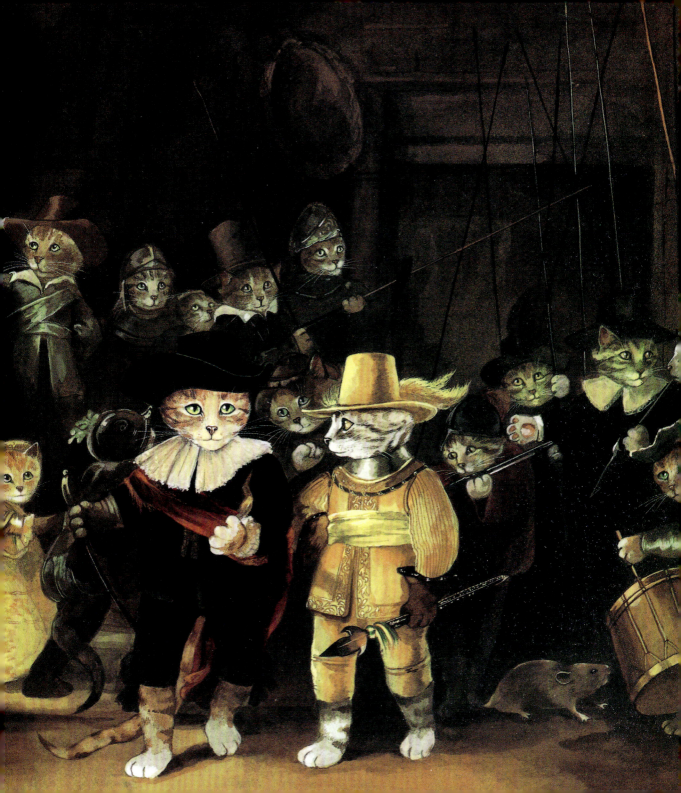

Diego Velázquez
The Toilet of Venus ('The Rokeby Venus')
c. 1647–51

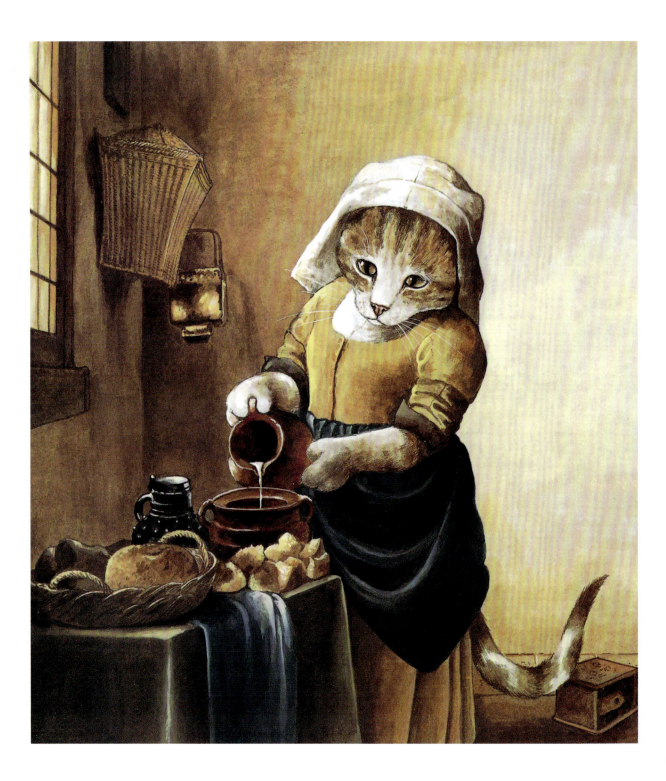

Johannes Vermeer
The Milkmaid
c. 1660

OVERLEAF, LEFT Johannes Vermeer, *Girl Reading a Letter at an Open Window, c.* 1659

OVERLEAF, RIGHT Johannes Vermeer, *Girl with the Red Hat, c.* 1665–6

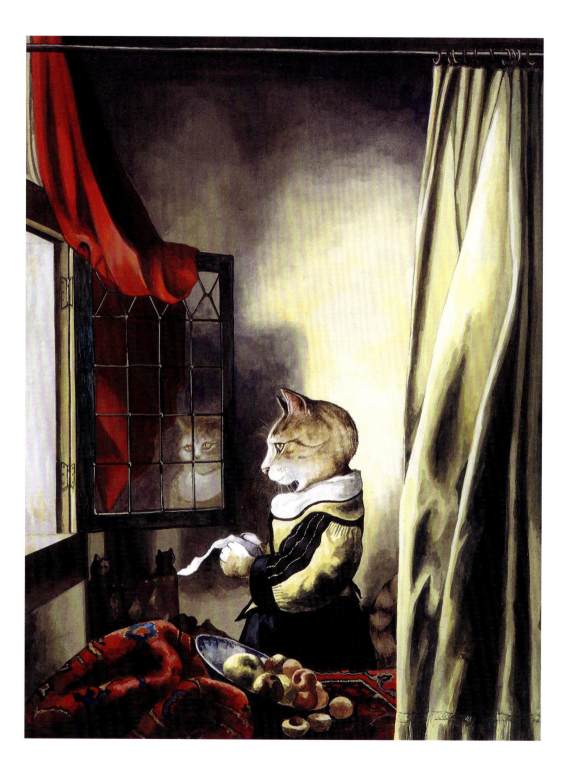

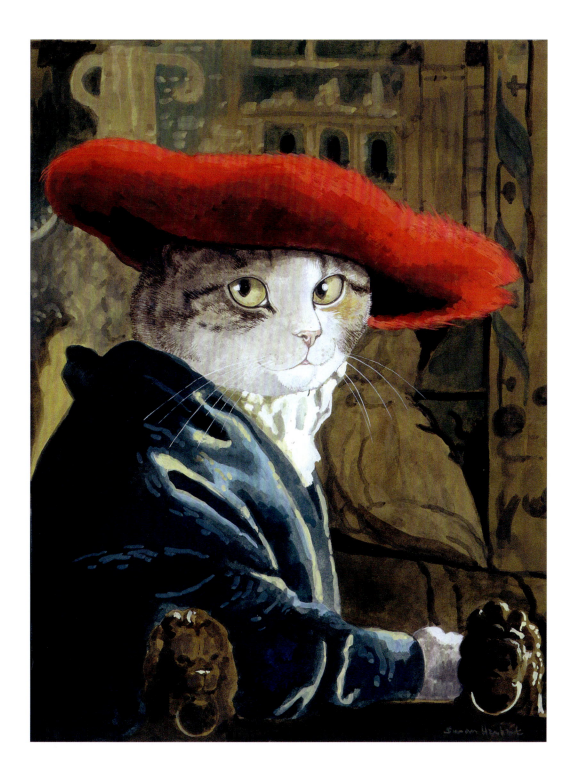

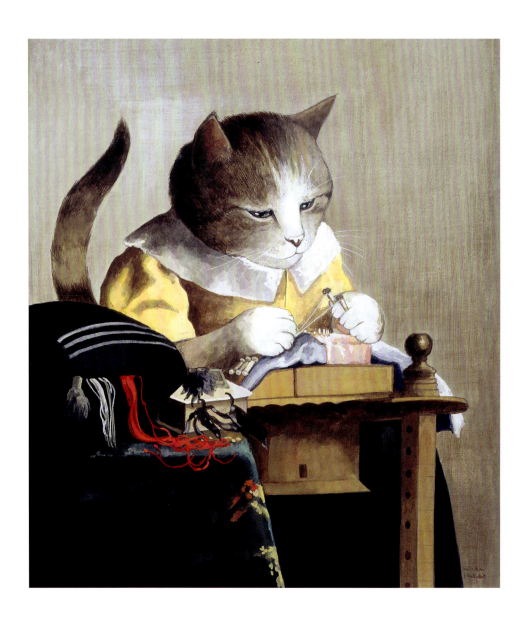

ABOVE Johannes Vermeer, *The Lacemaker*, 1669–70

OPPOSITE Johannes Vermeer, *The Guitar Player*, 1670–2

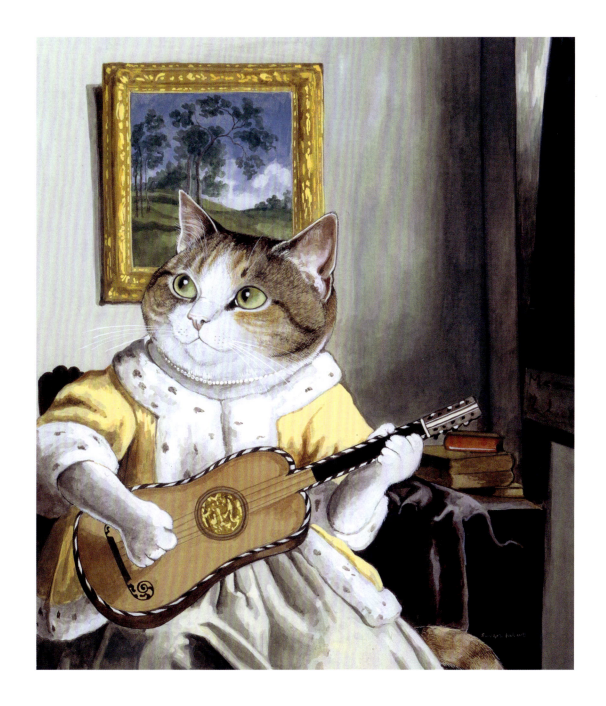

Hyacinthe Rigaud
Portrait of Louis XIV
1701

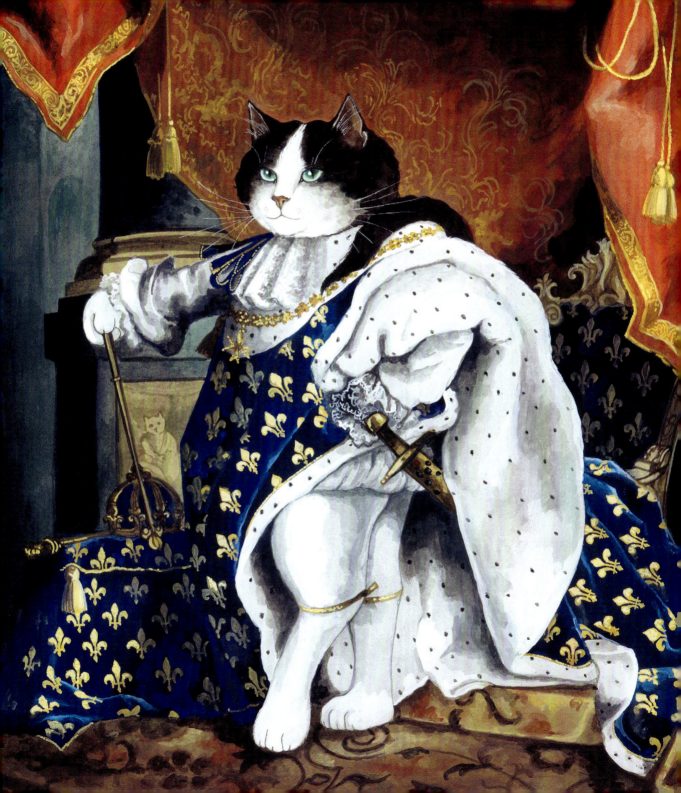

Jean-Antoine Watteau
Fêtes Vénitiennes
1718–19

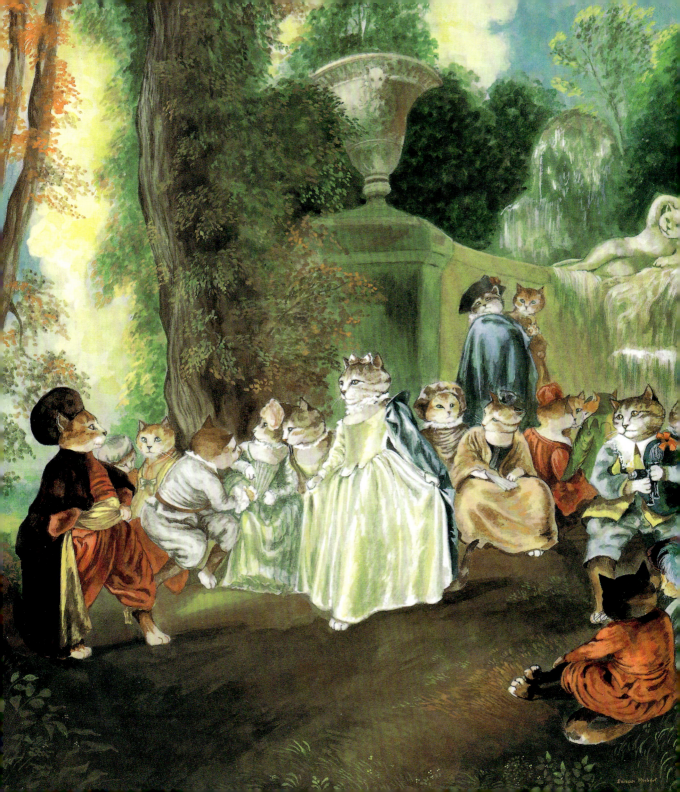

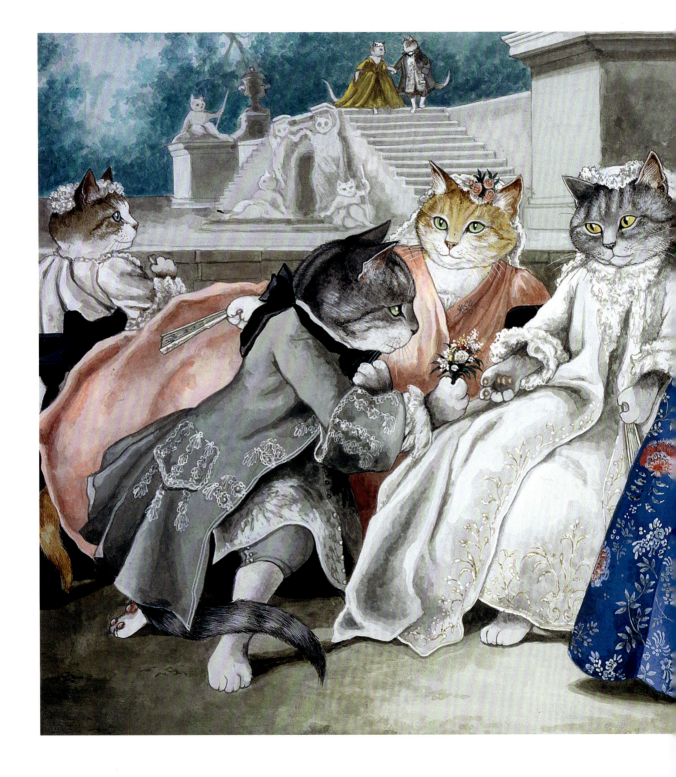

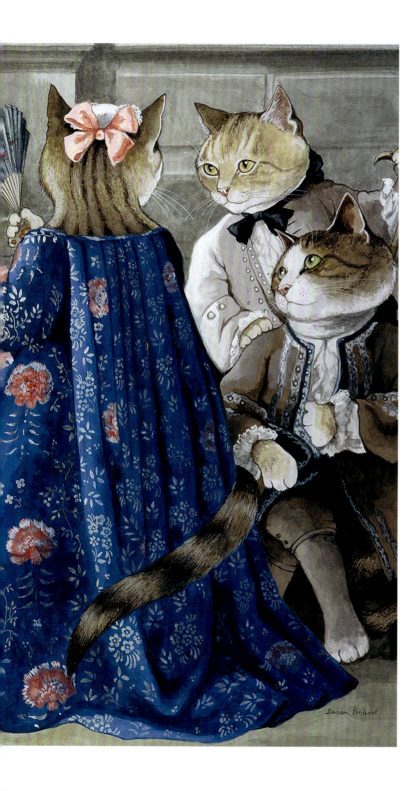

Jean François de Troy
The Declaration of Love
1731

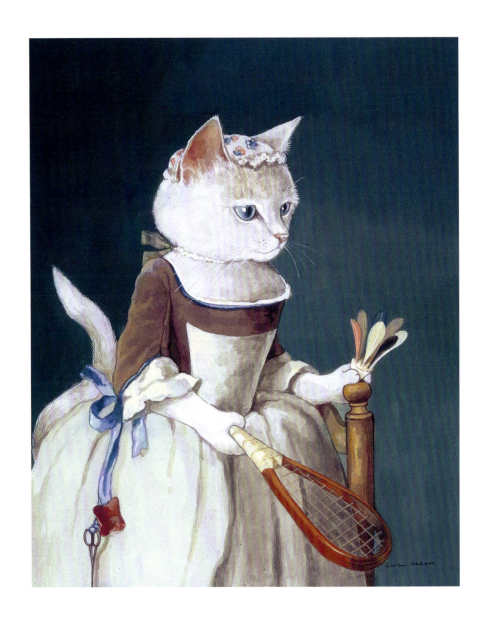

Jean-Baptiste-Siméon Chardin, *Girl with a Racket*, 1737

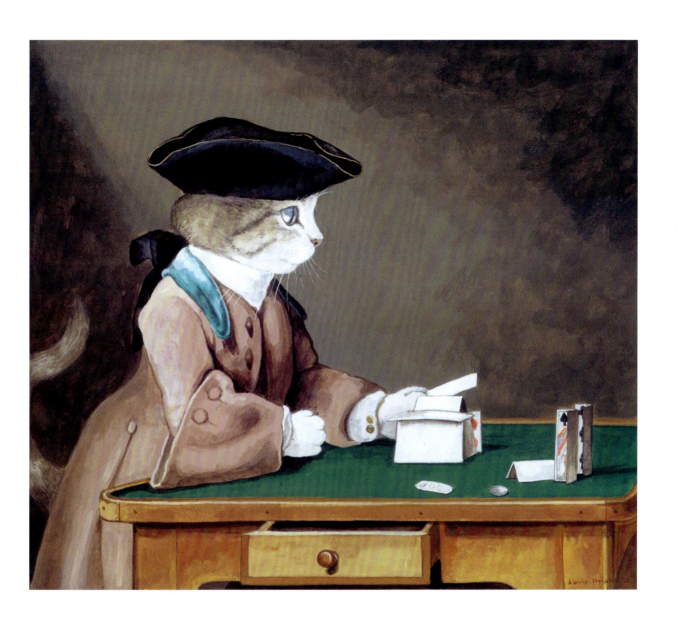

Jean-Baptiste-Siméon Chardin, *The House of Cards*, c. 1740–1

William Hogarth
A Rake's Progress (The Tavern Scene)
1732–3

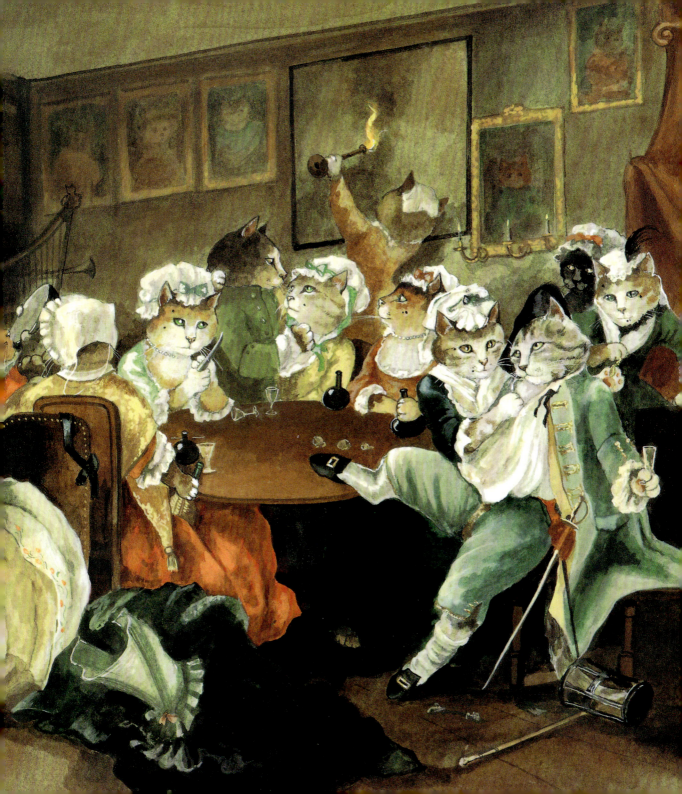

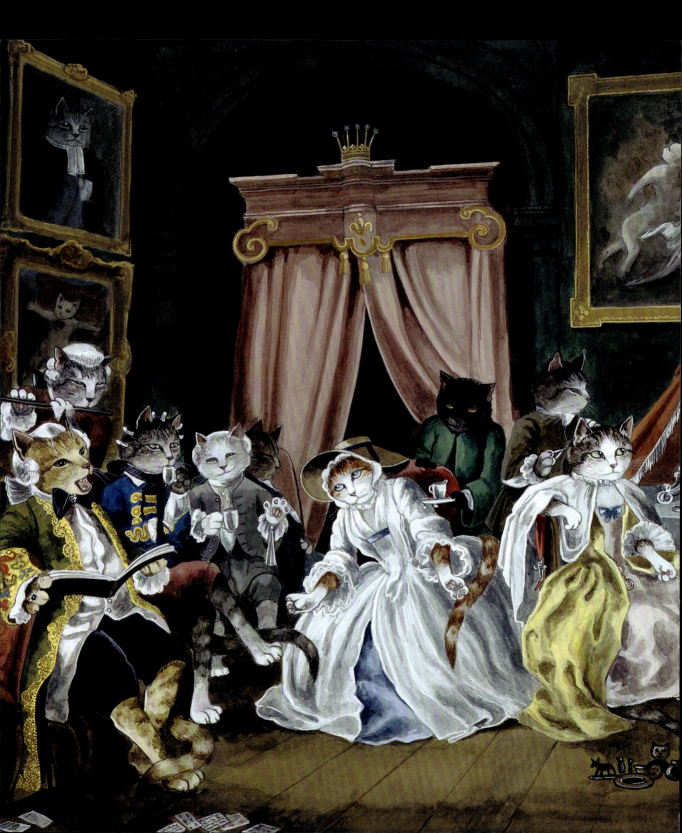

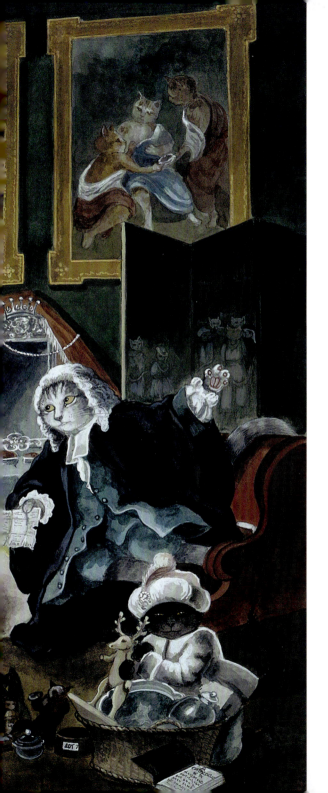

William Hogarth
Marriage à la Mode (The Toilette)
c. 1743

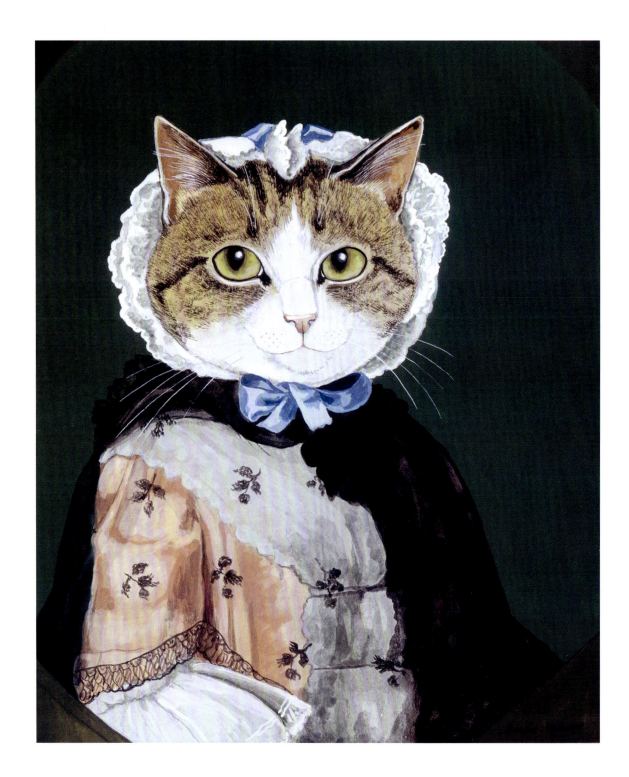

Allan Ramsay
Rosamund Sargent, née Chambers
1749

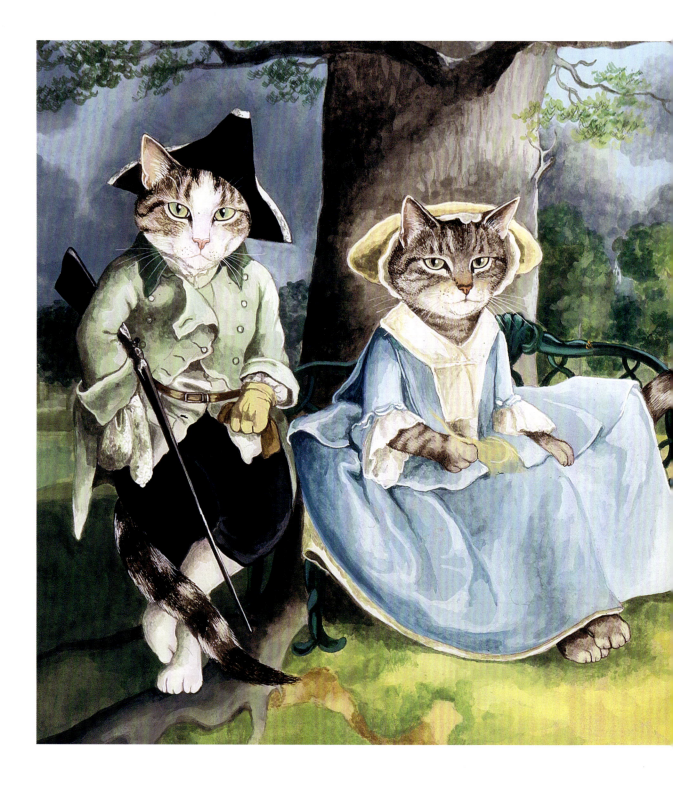

Thomas Gainsborough
Mr and Mrs Andrews
c. 1750

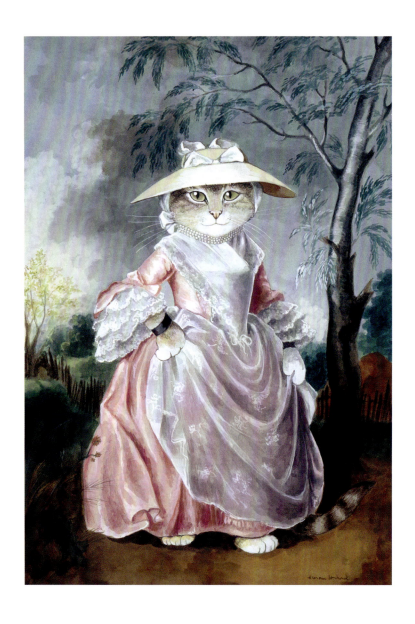

ABOVE Thomas Gainsborough, *Mary, Countess Howe*, 1760

OPPOSITE Thomas Gainsborough, *Mr and Mrs William Hallett ('The Morning Walk')*, 1785

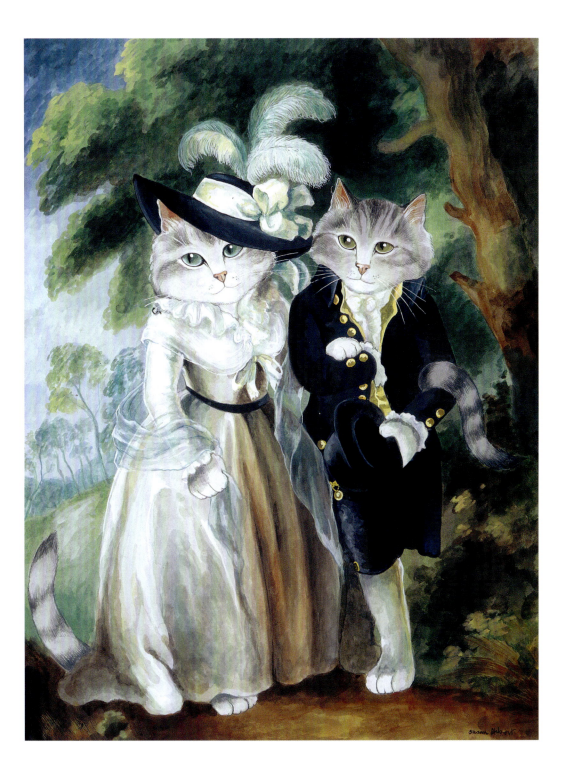

Thomas Gainsborough
Mrs Siddons
1785

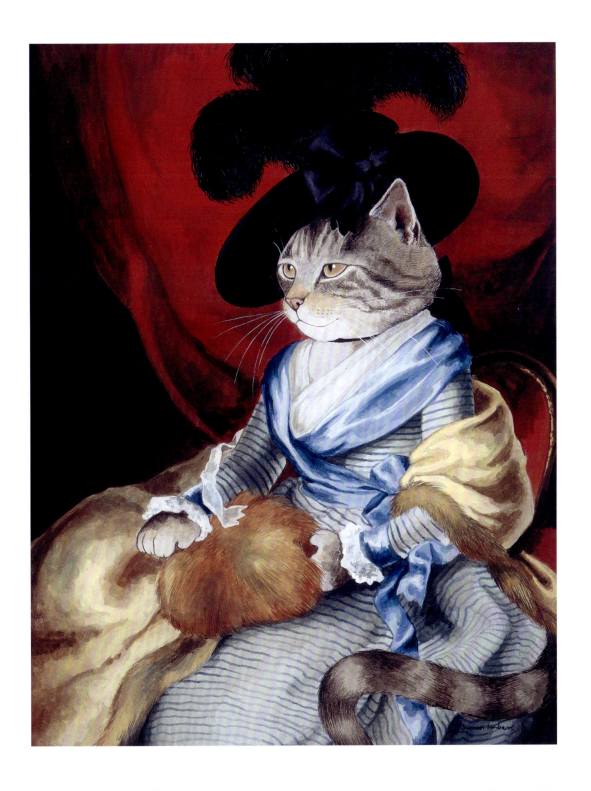

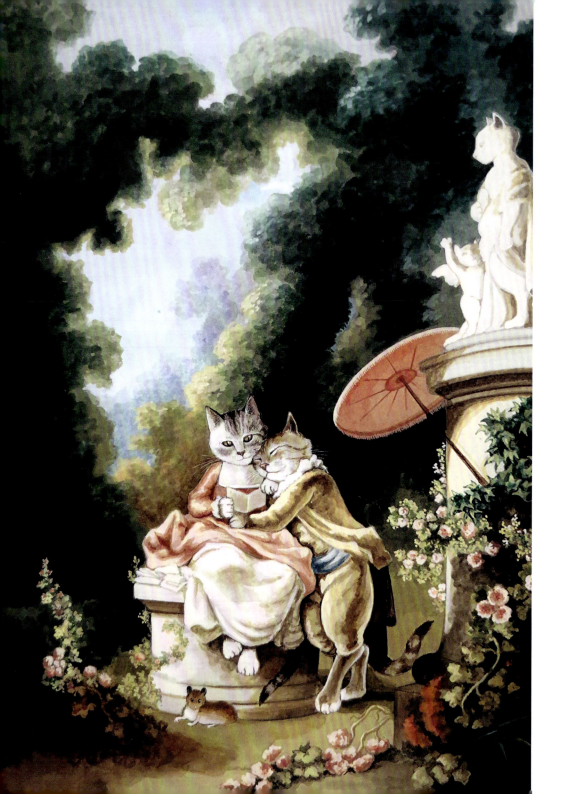

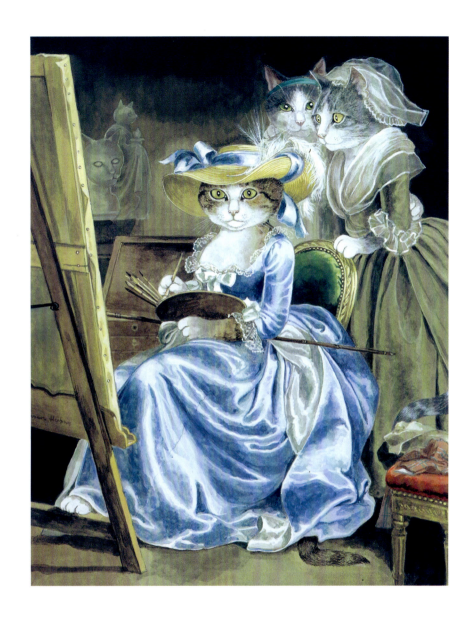

ABOVE Adélaïde Labille-Guiard, *Self-Portrait with Two Pupils*, 1785

OPPOSITE Jean-Honoré Fragonard, *The Progress of Love: Love Letters*, 1771–2

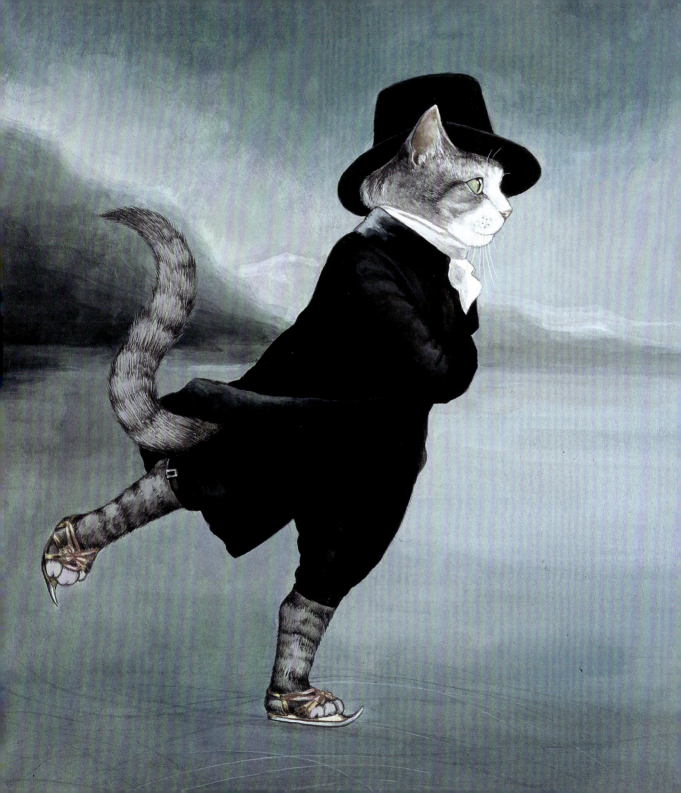

Henry Raeburn
The Skating Minister
c. 1795

Jacques-Louis David
The Death of Socrates
1787

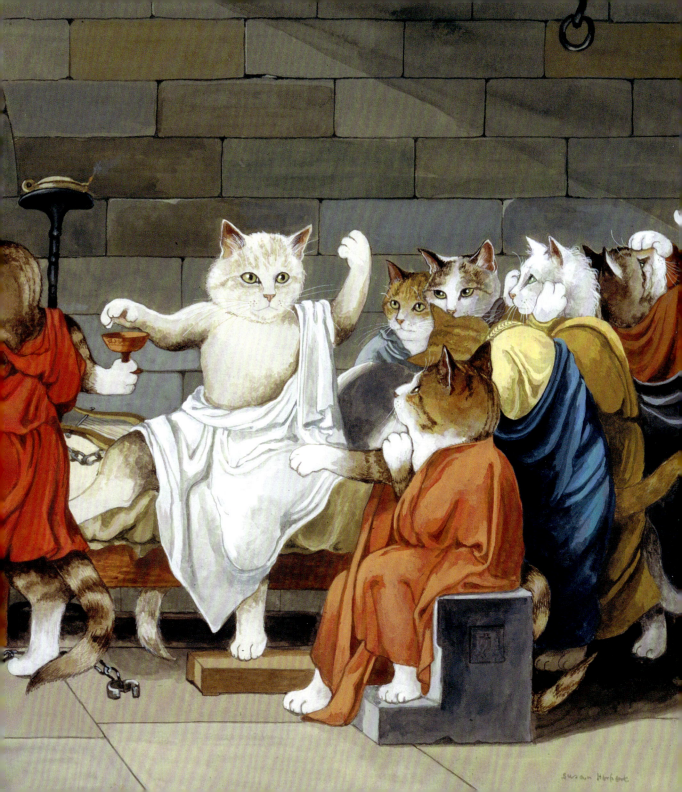

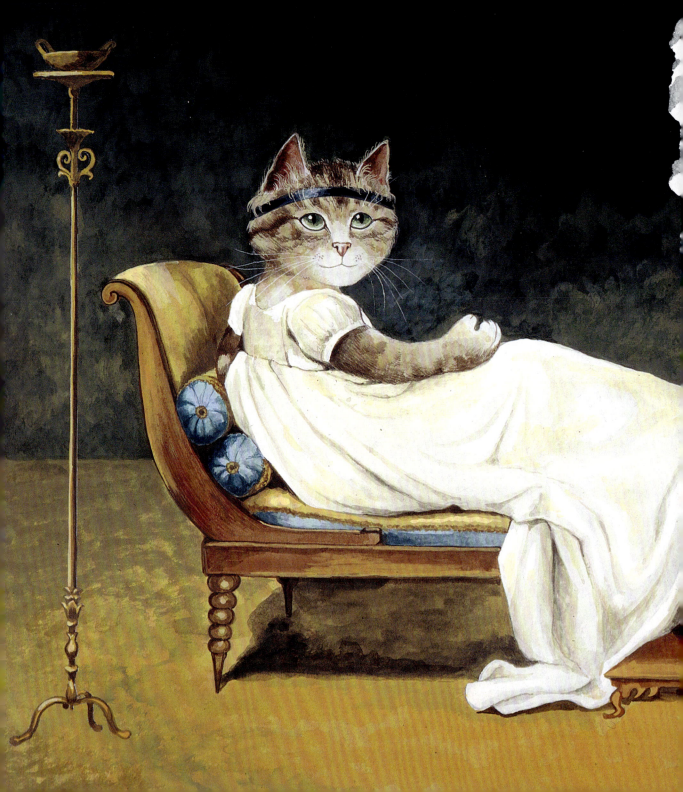

Jacques-Louis David
Madame Récamier
1800

Francisco Goya
The Family of Charles IV
1800

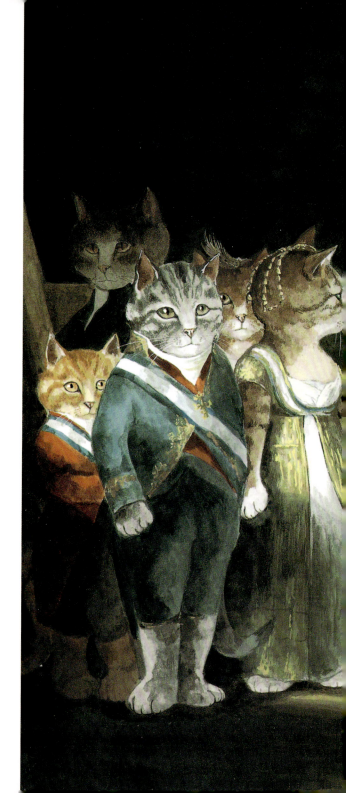

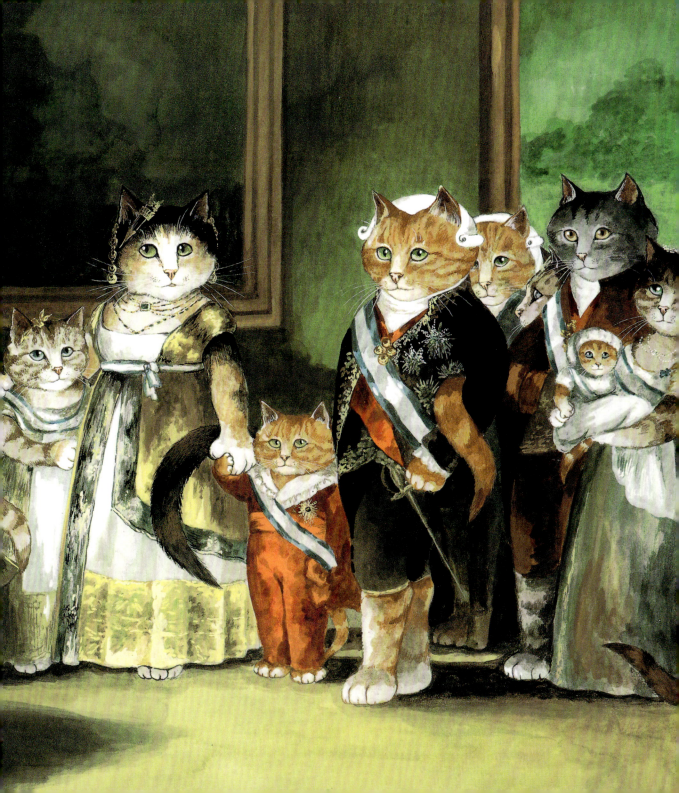

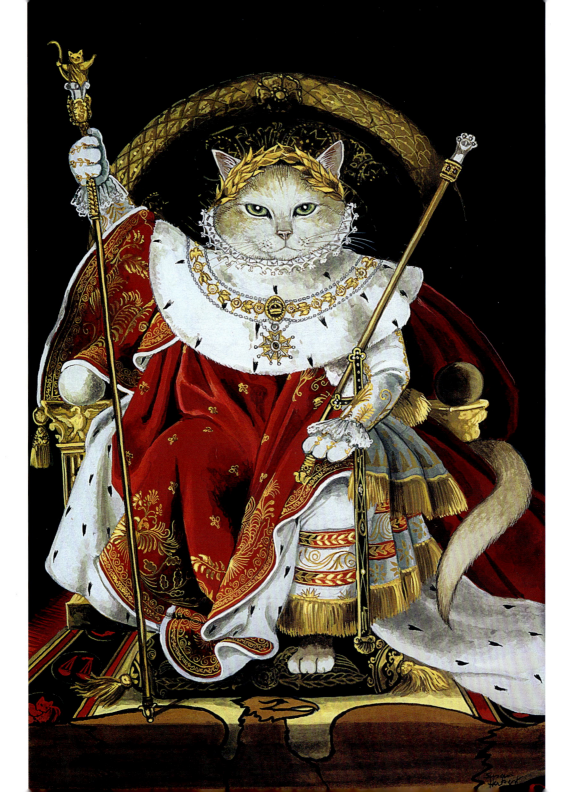

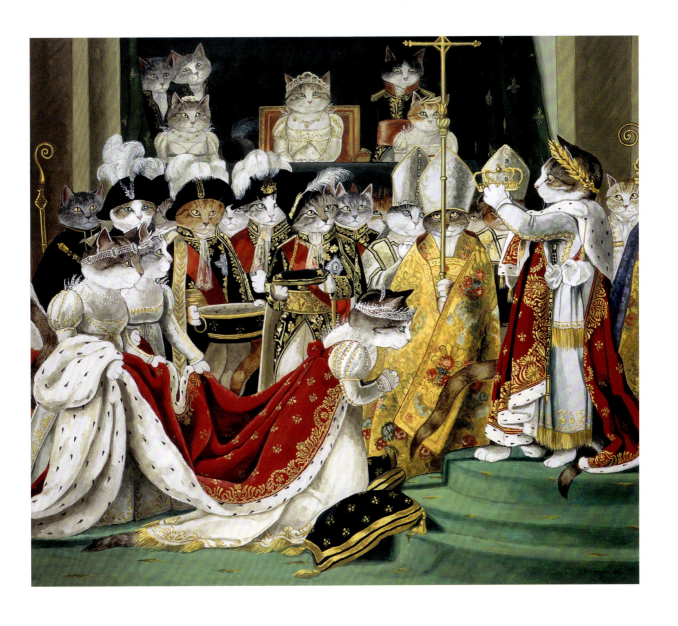

ABOVE Jacques-Louis David, *The Coronation of Napoleon*, 1806–7

OPPOSITE Jean-Auguste-Dominique Ingres, *Napoleon I on his Imperial Throne*, 1806

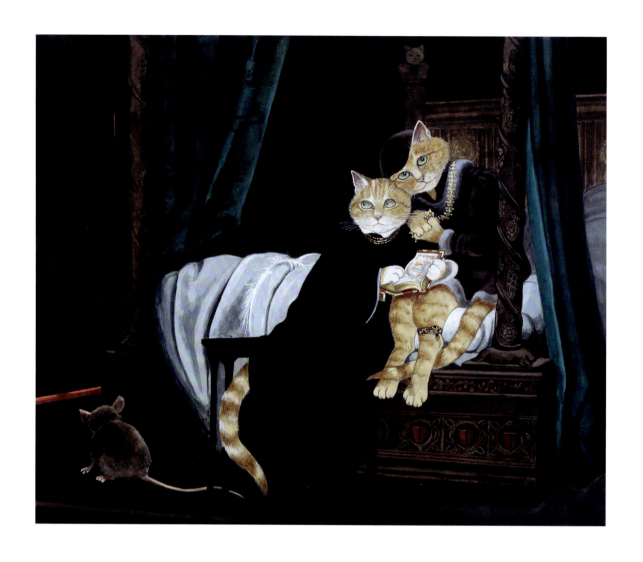

ABOVE Paul Delaroche, *Children of Edward*, 1831

OPPOSITE Eugène Delacroix, *Greece on the Ruins of Missolonghi*, 1826

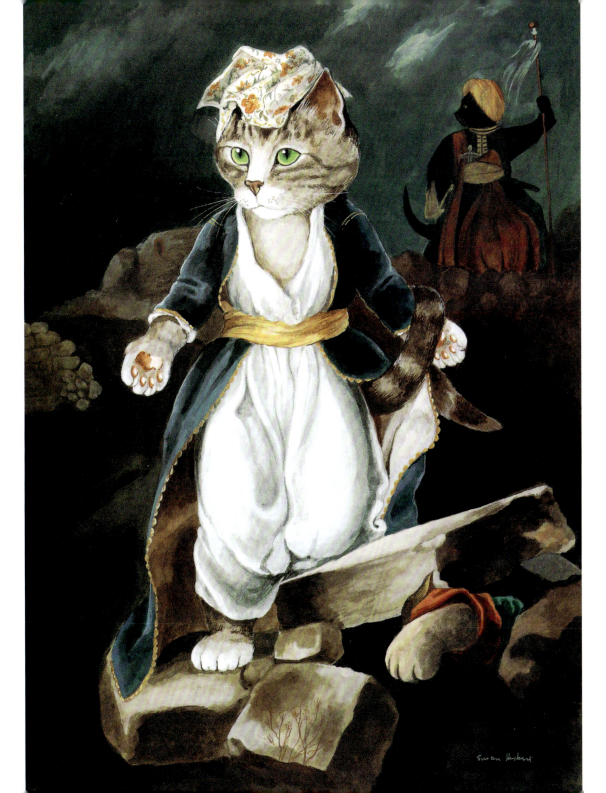

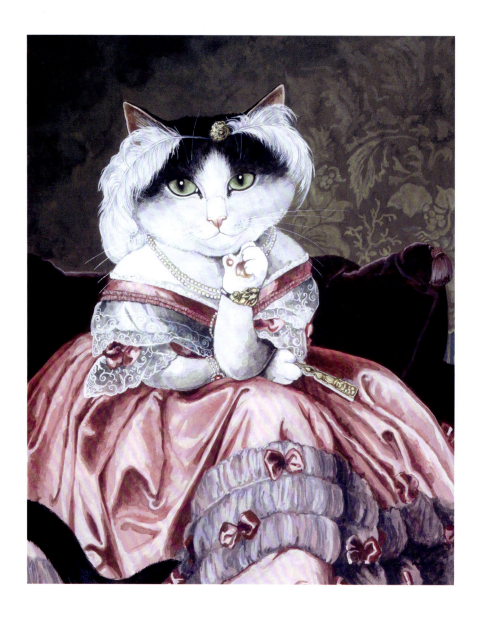

ABOVE Jean-Auguste-Dominique Ingres, *Baronne de Rothschild*, 1848

OPPOSITE Jean-Auguste-Dominique Ingres, *Monsieur Bertin*, 1832

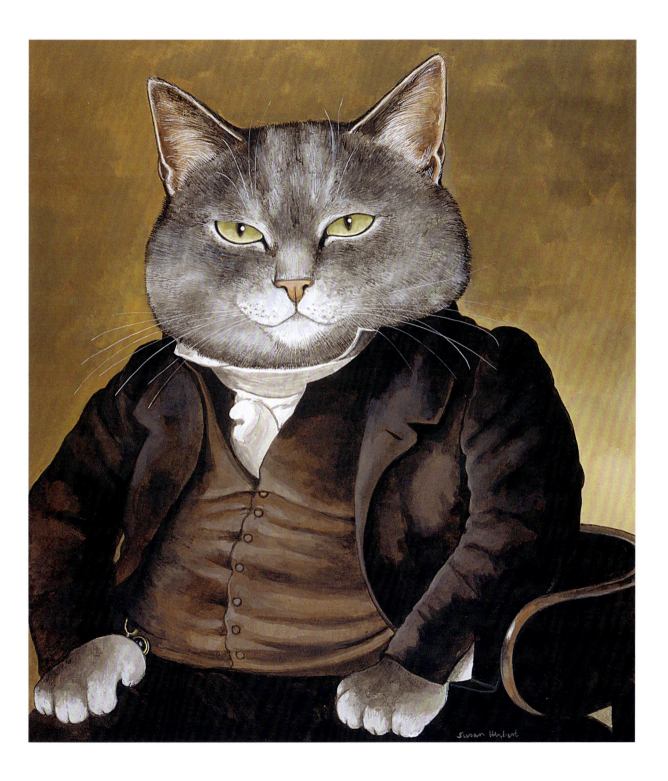

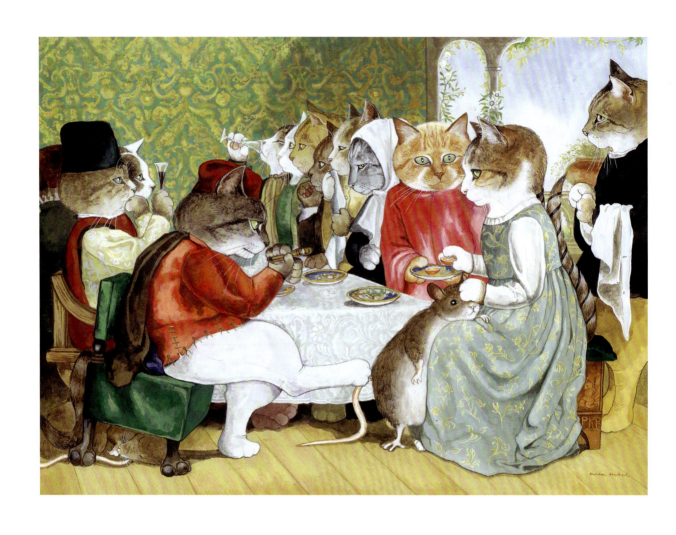

ABOVE John Everett Millais, *Isabella*, 1849

OPPOSITE William Holman Hunt, *Claudio and Isabella*, 1850

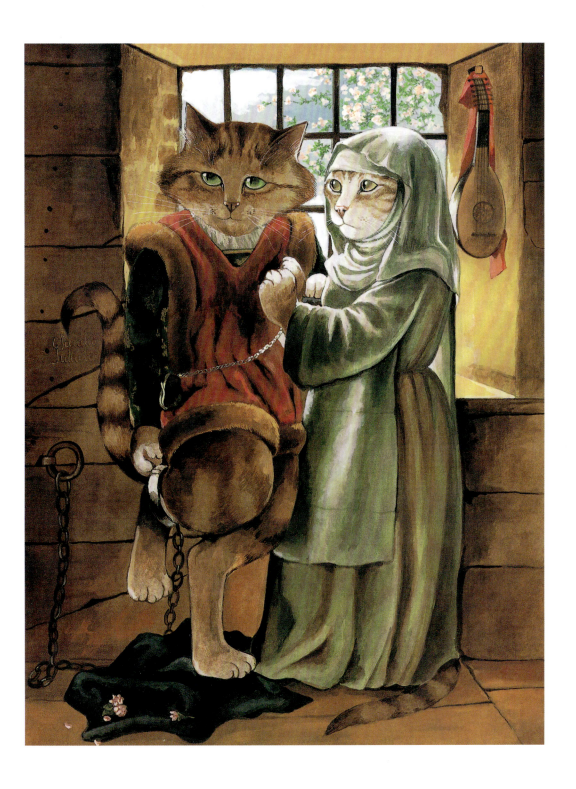

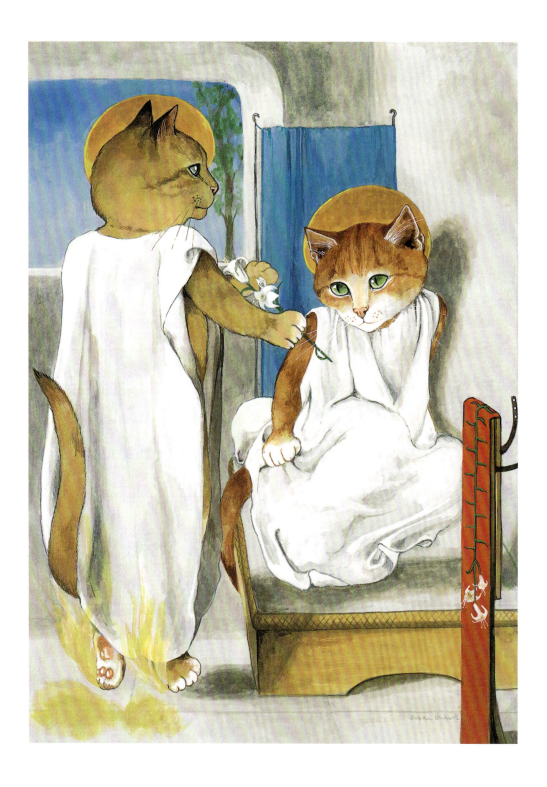

Dante Gabriel Rossetti
Ecce Ancilla Domini! (The Annunciation)
1849–50

John Everett Millais
Mariana
1851

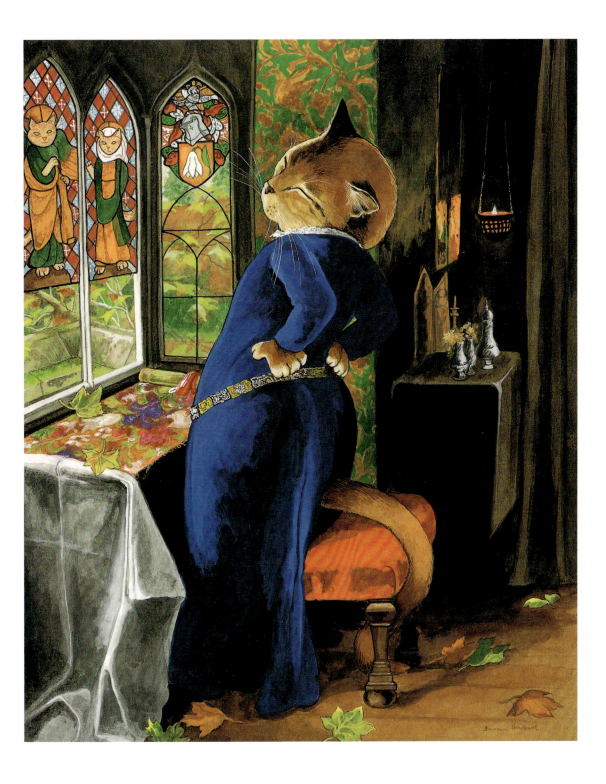

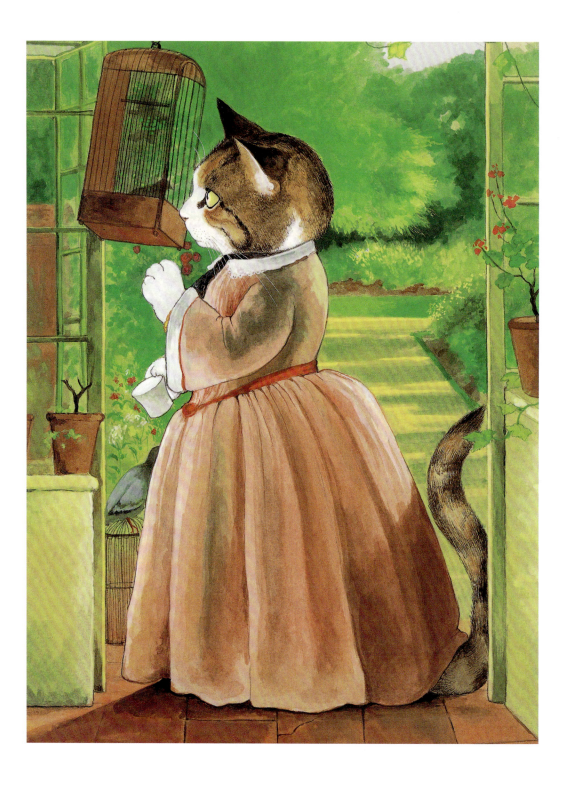

Walter Howell Deverell
A Pet
1853

OVERLEAF, LEFT William Holman Hunt, *The Awakening Conscience*, 1853

OVERLEAF, RIGHT William Holman Hunt, *The Light of the World*, 1853

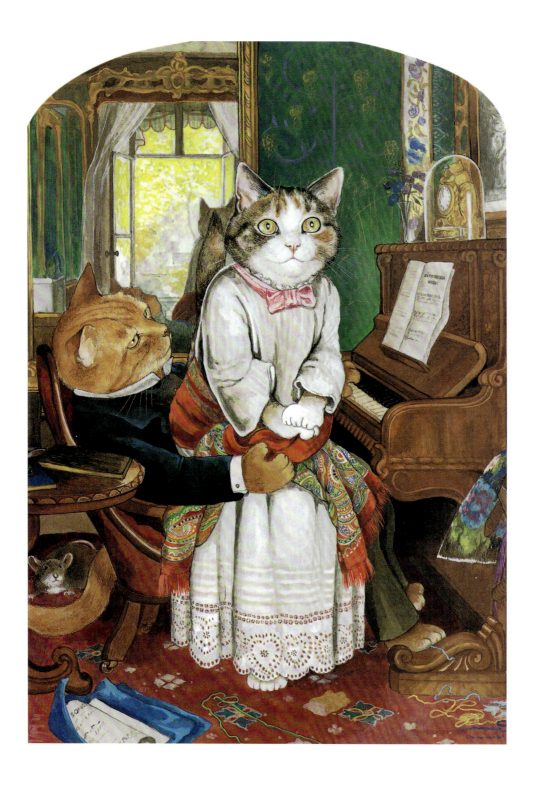

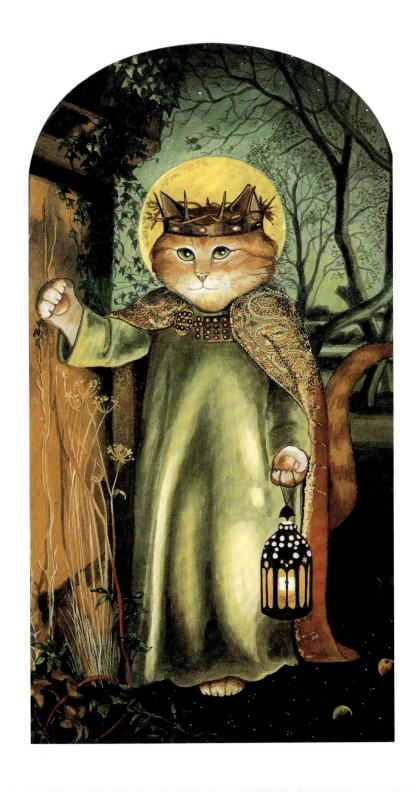

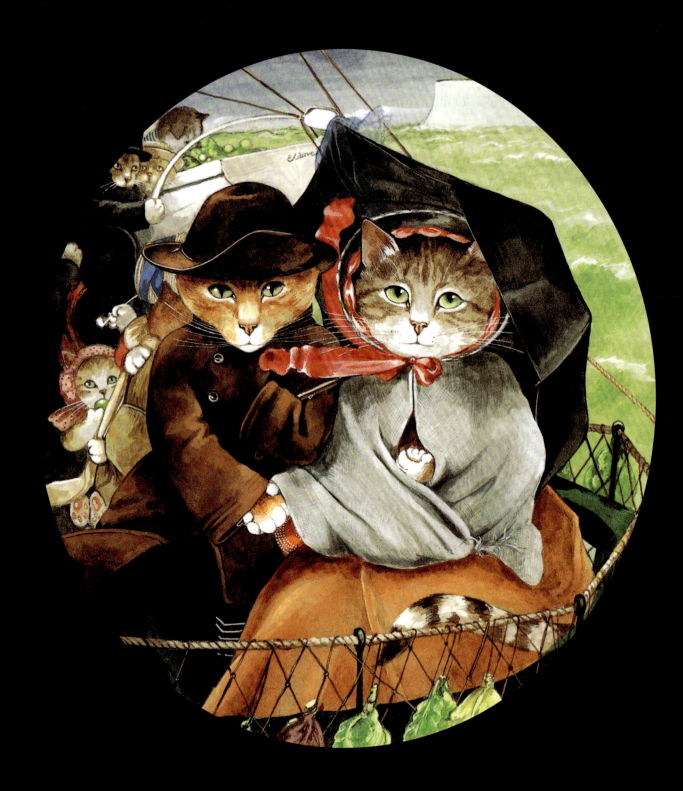

Ford Madox Brown
The Last of England
1855

Franz Xaver Winterhalter
The Cousins: Queen Victoria and Victoire, Duchesse de Nemours
1852

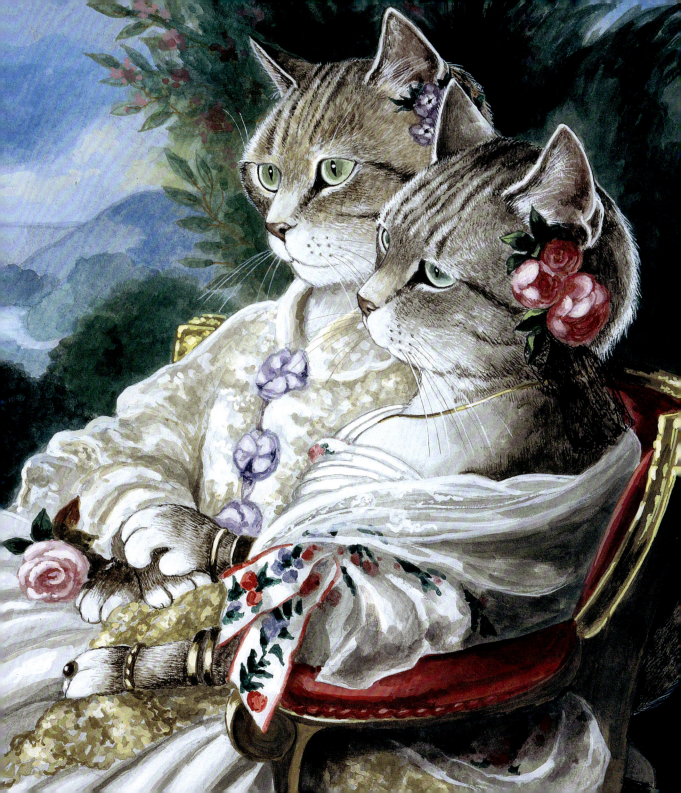

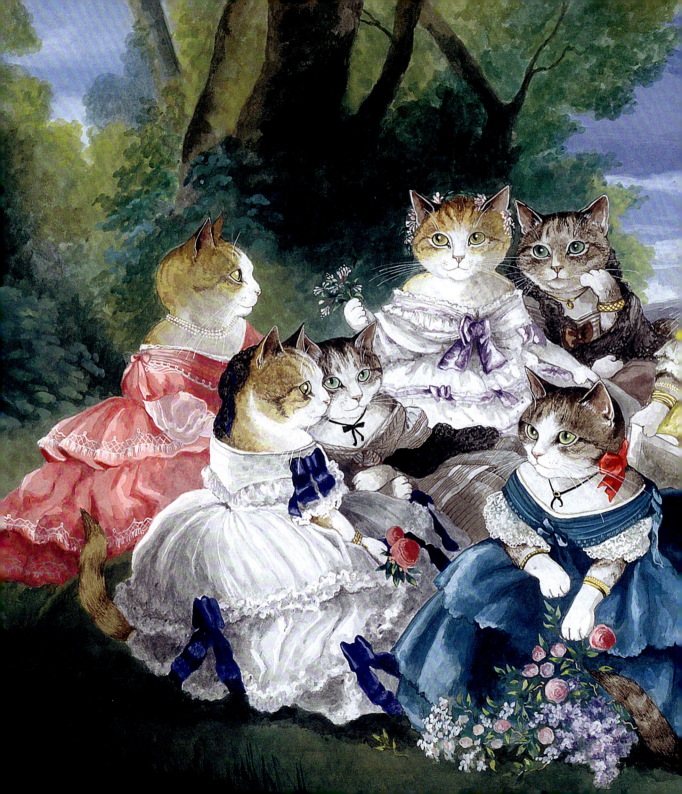

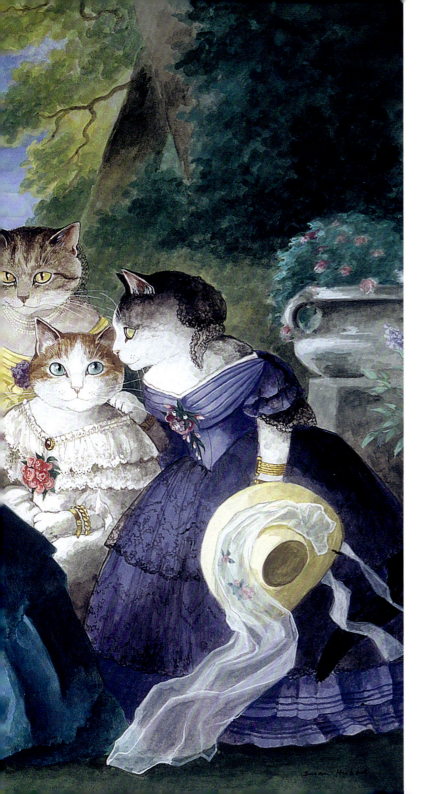

Franz Xaver Winterhalter
Empress Eugénie Surrounded by her Ladies in Waiting
1855

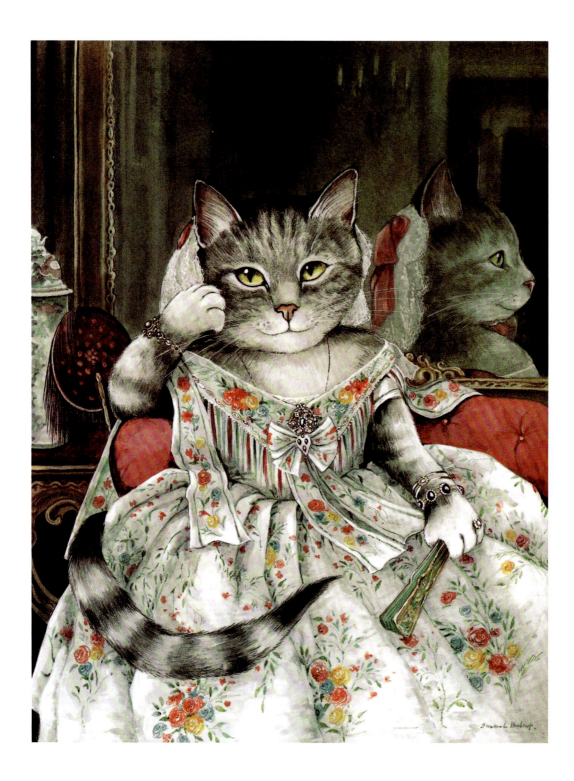

Jean-Auguste-Dominique Ingres
Portrait of Madame Moitessier
1856

OVERLEAF, LEFT Arthur Hughes, *The Long Engagement*, 1854–9

OVERLEAF, RIGHT Arthur Hughes, *April Love*, 1855–6

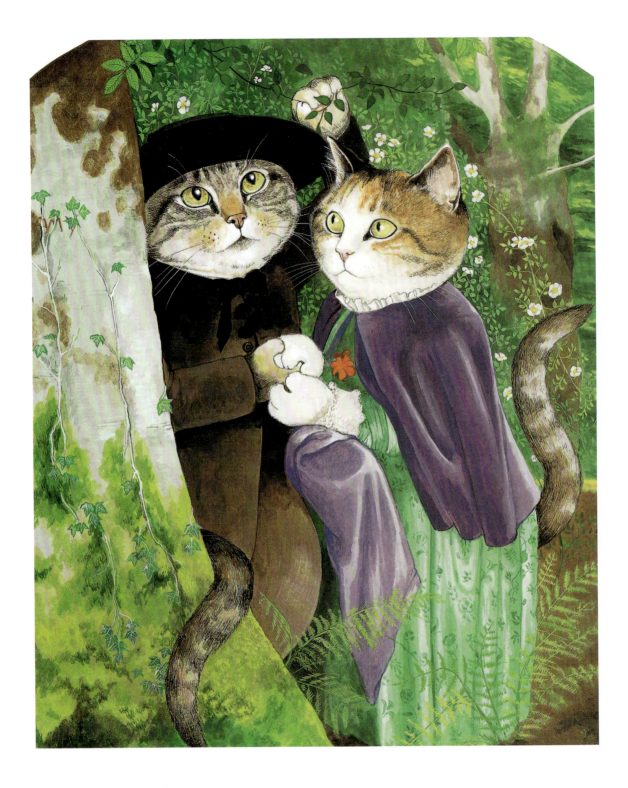

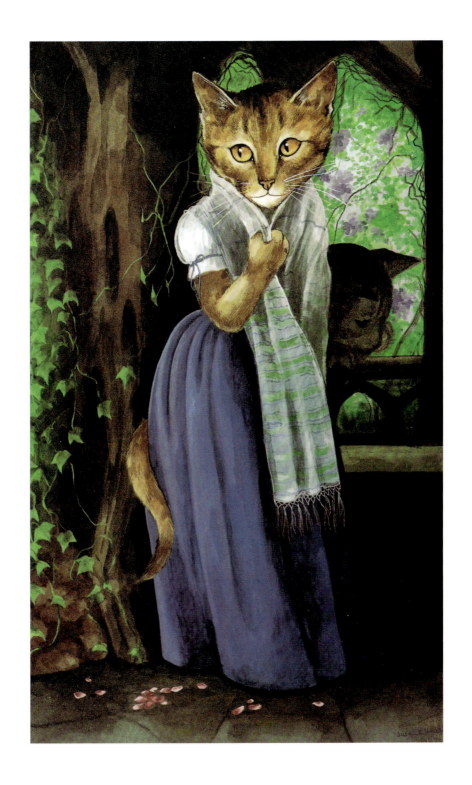

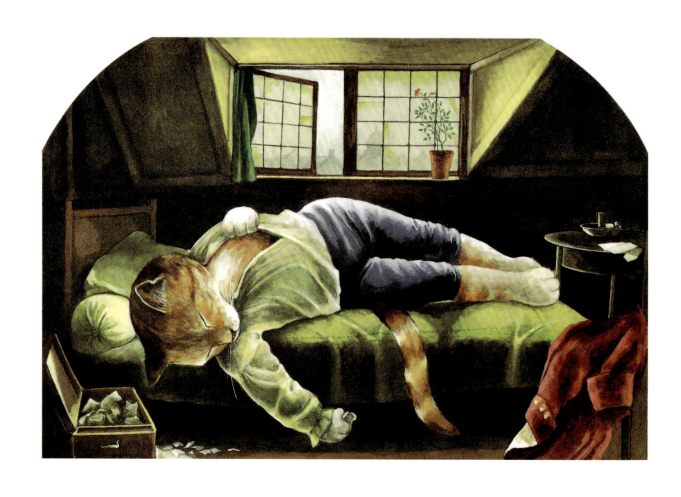

ABOVE Henry Wallis, *Chatterton*, 1856

OPPOSITE George Frederic Watts, *Mrs Nassau John Senior*, 1857–8

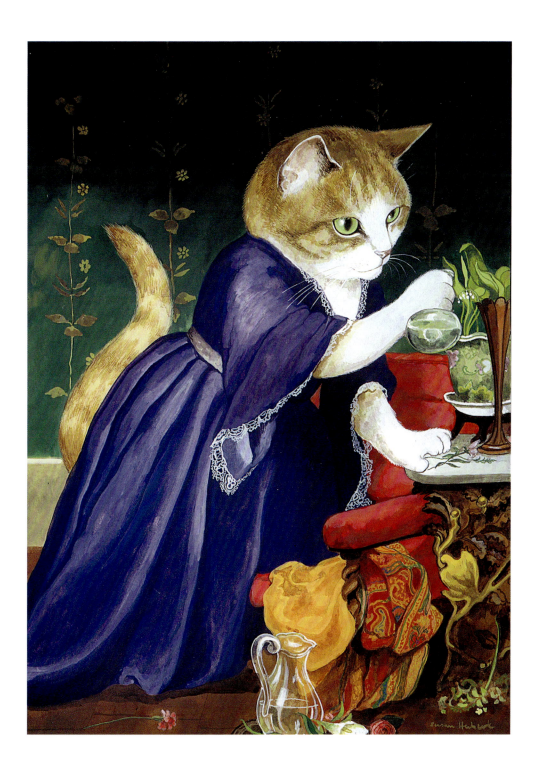

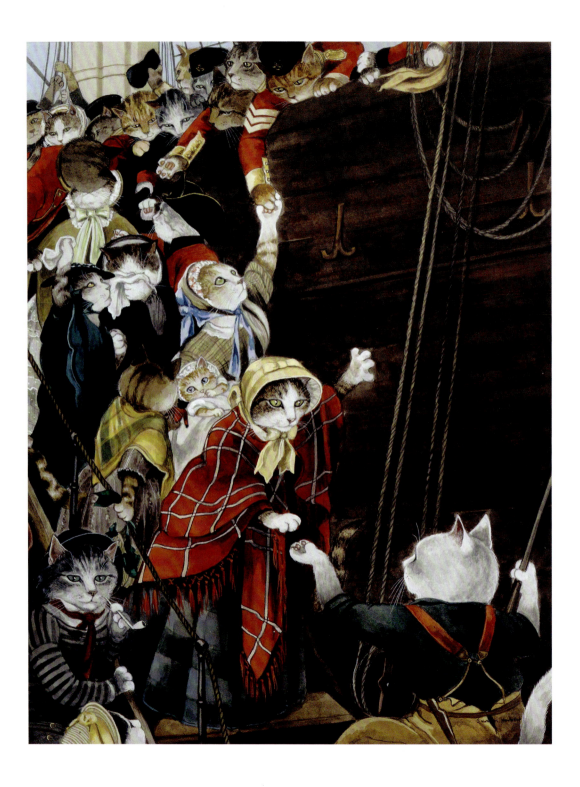

Henry Nelson O'Neil
Eastward Ho!
1857

William Maw Egley
Omnibus Life in London
1859

OVERLEAF
Daniel Maclise, *The Death of Nelson*, 1859–64

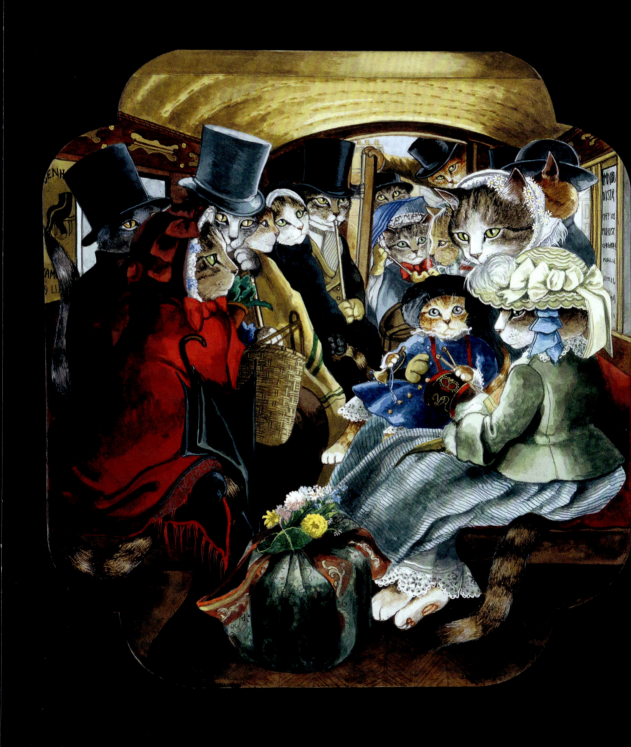

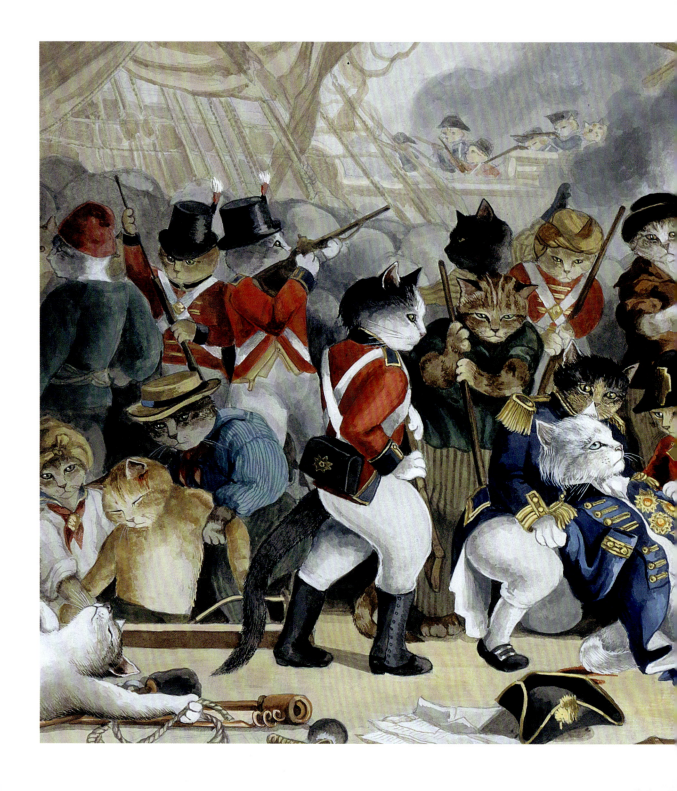

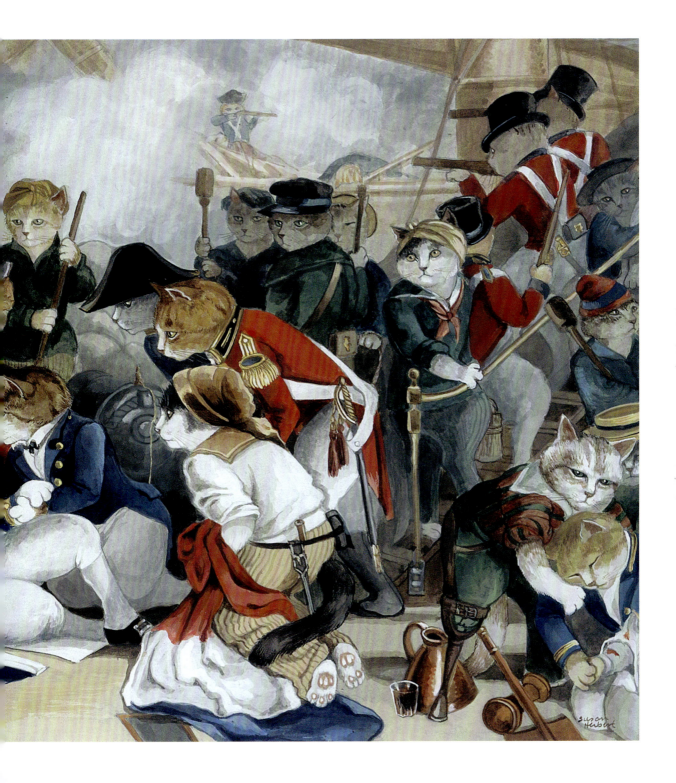

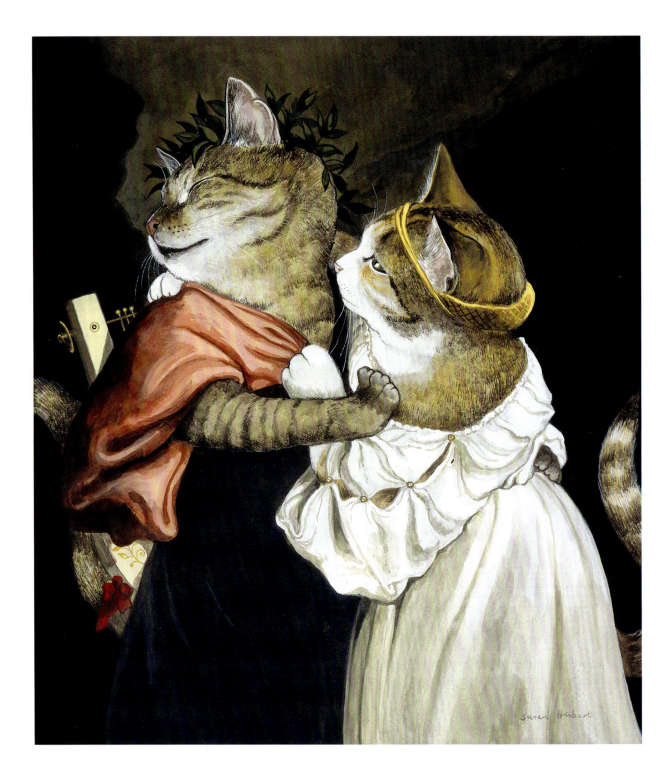

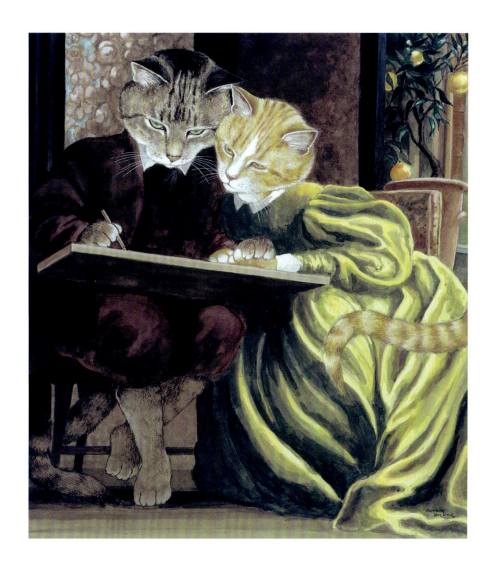

ABOVE Frederic Leighton, *The Painter's Honeymoon*, c. 1864

OPPOSITE Frederic Leighton, *Orpheus and Eurydice*, 1864

OVERLEAF, LEFT Dante Gabriel Rossetti, *Monna Vanna*, 1866

OVERLEAF, RIGHT Dante Gabriel Rossetti, *The Beloved*, 1865–6

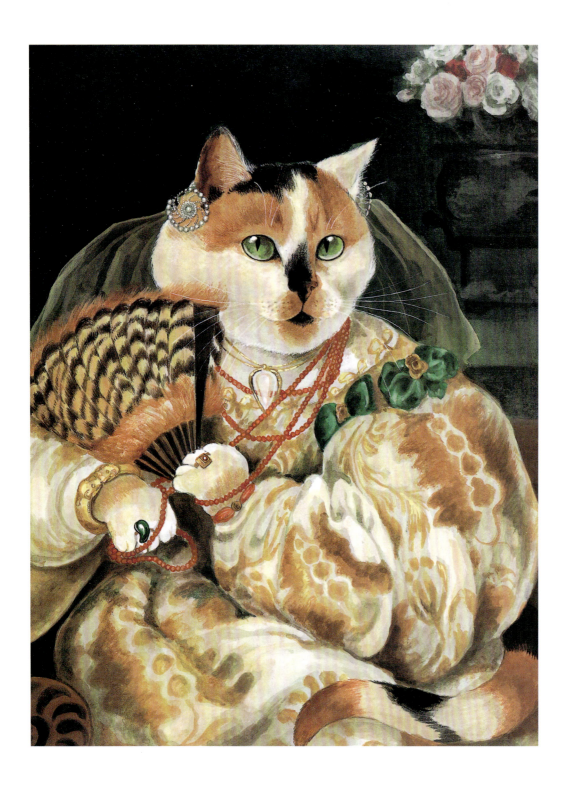

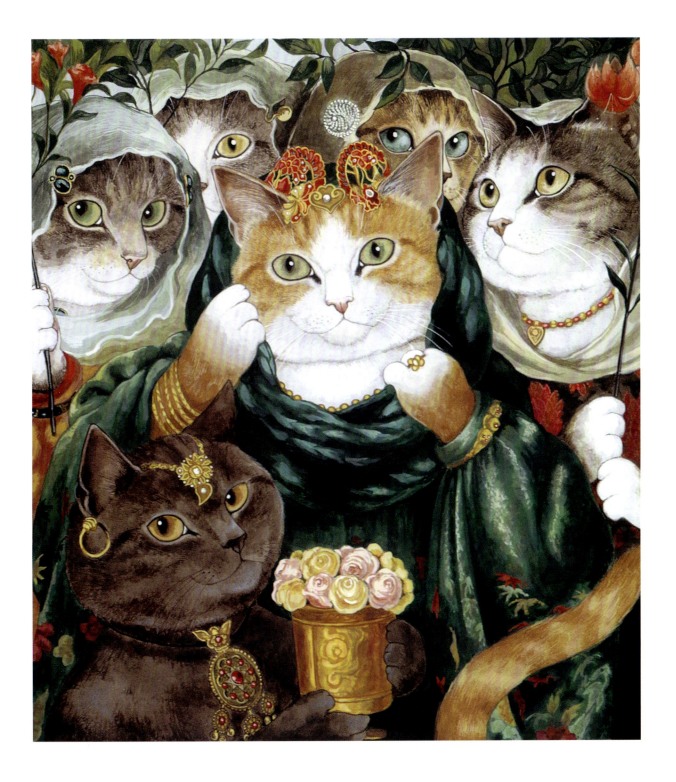

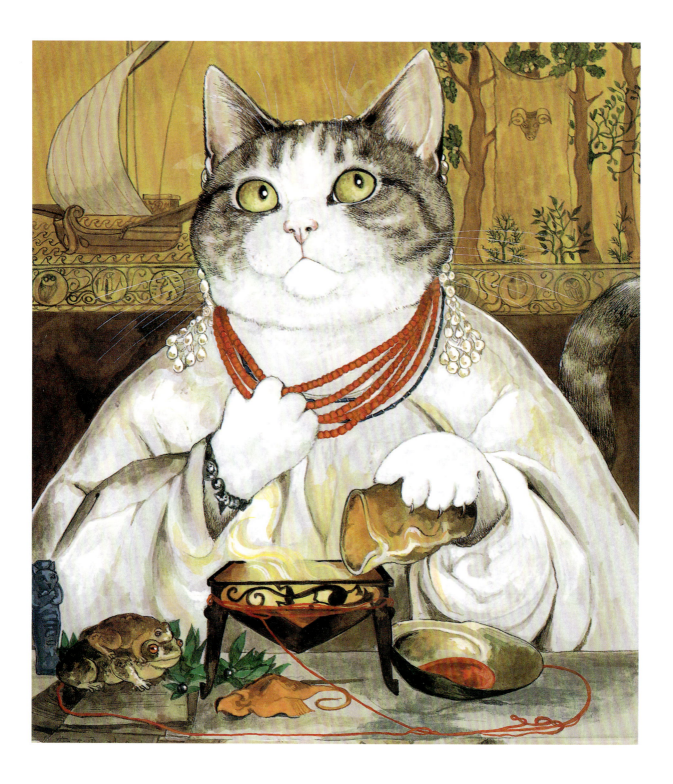

Frederick Sandys
Medea
1868

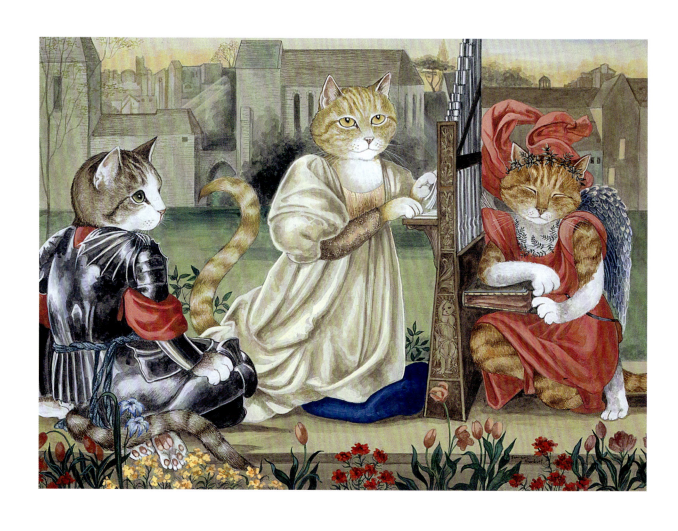

ABOVE Edward Burne-Jones, *Le Chant d'Amour*, 1868–77

OPPOSITE Edward Burne-Jones, *Love Among the Ruins*, 1873

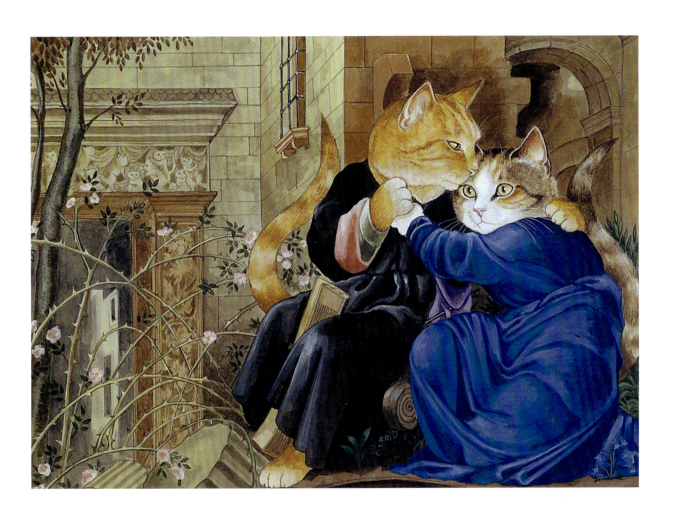

OVERLEAF, LEFT Edward Burne-Jones, *The Beguiling of Merlin*, 1872–7

OVERLEAF, RIGHT Dante Gabriel Rossetti, *Proserpine*, 1874

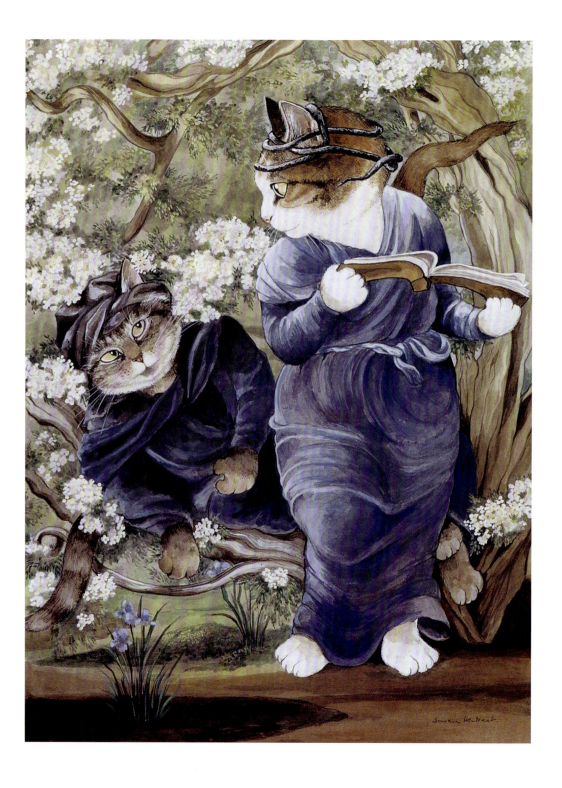

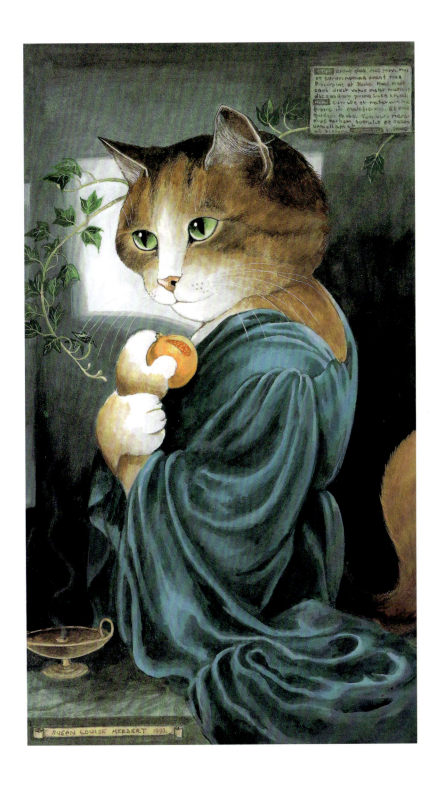

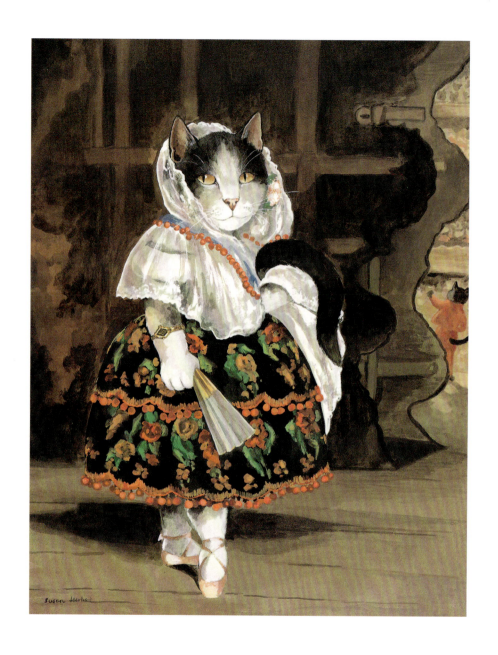

Édouard Manet, *Lola de Valence*, 1862

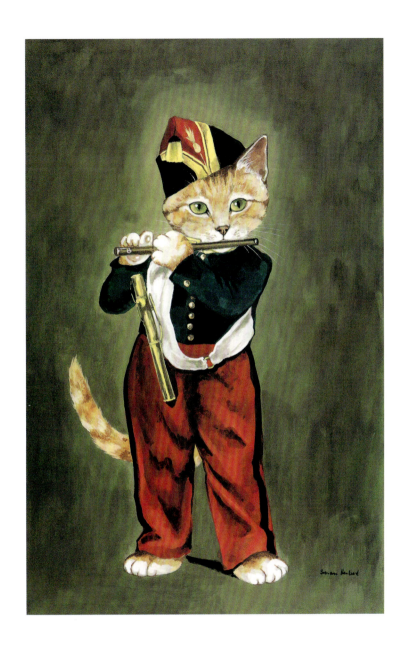

Édouard Manet, *The Fife Player*, 1866

Édouard Manet
Le Déjeuner sur l'herbe
1862–3

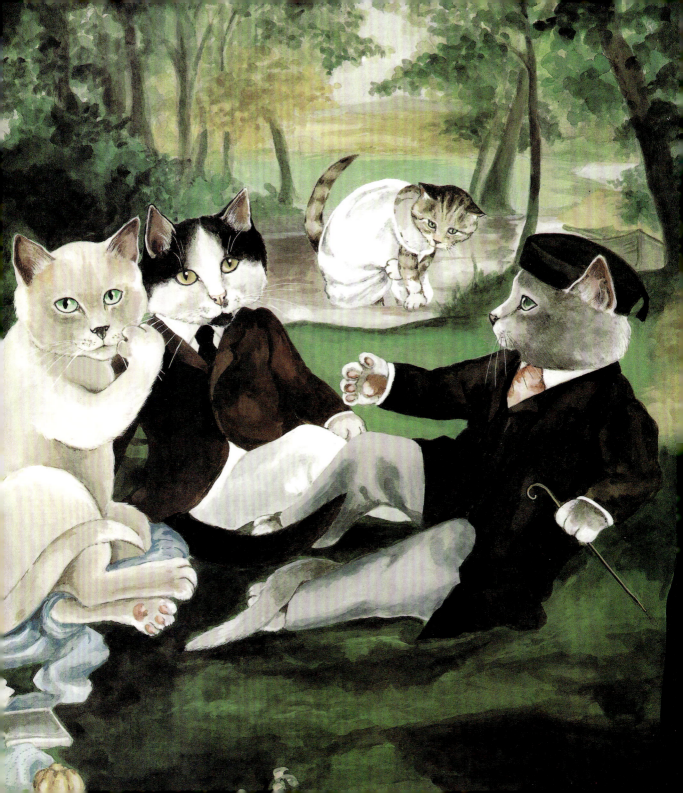

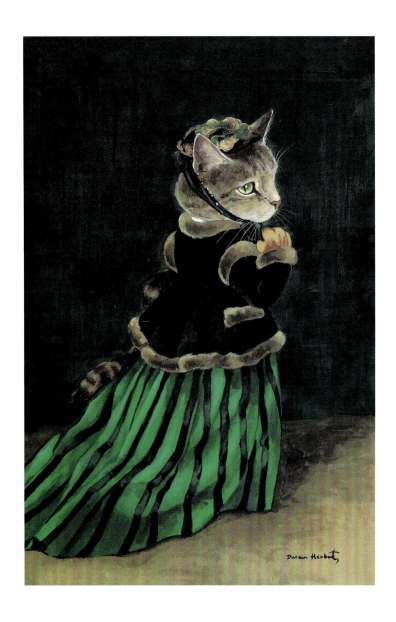

ABOVE Claude Monet, *Camille*, 1866

OPPOSITE Claude Monet, *Women in the Garden*, c. 1866

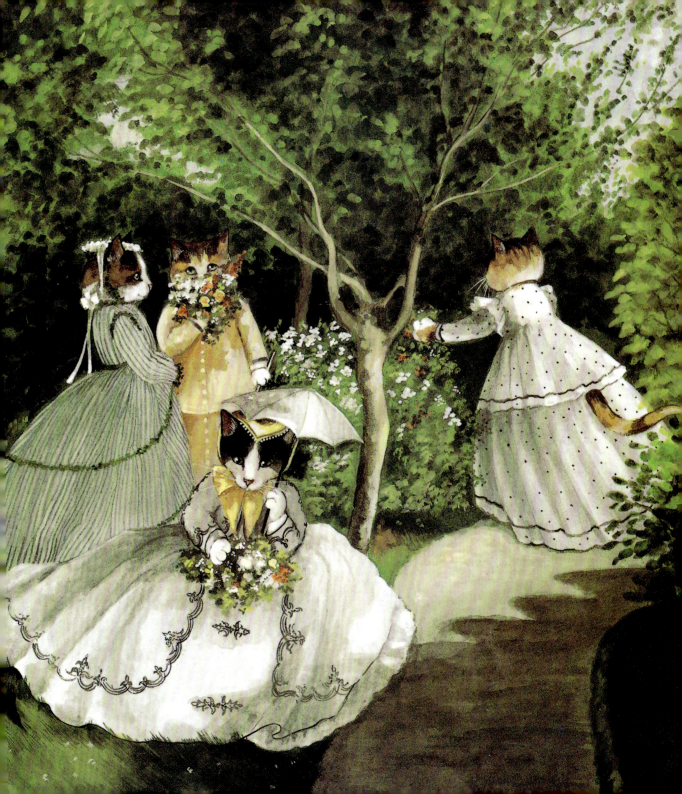

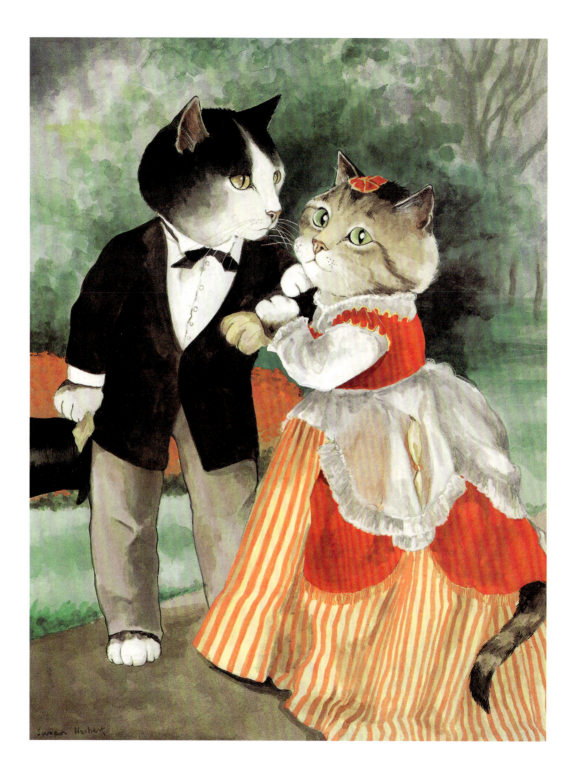

Pierre-Auguste Renoir
A Couple
c. 1868

OVERLEAF, LEFT Édouard Manet, *The Balcony*, 1868–9

OVERLEAF, RIGHT Édouard Manet, *Eva Gonzalès*, 1870

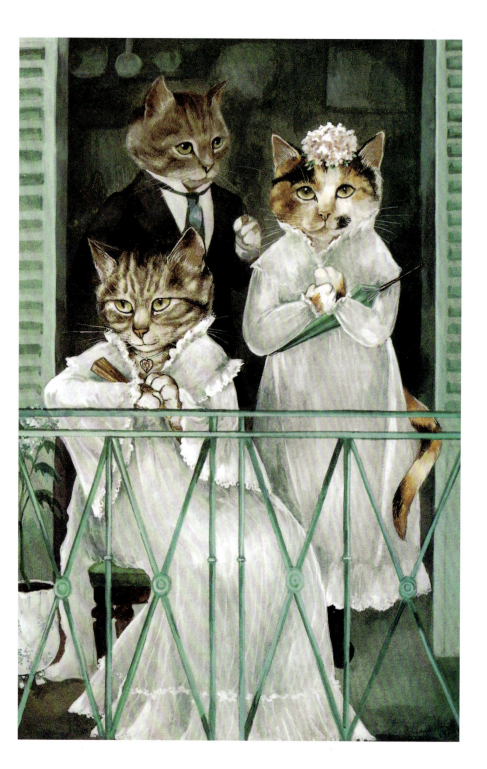

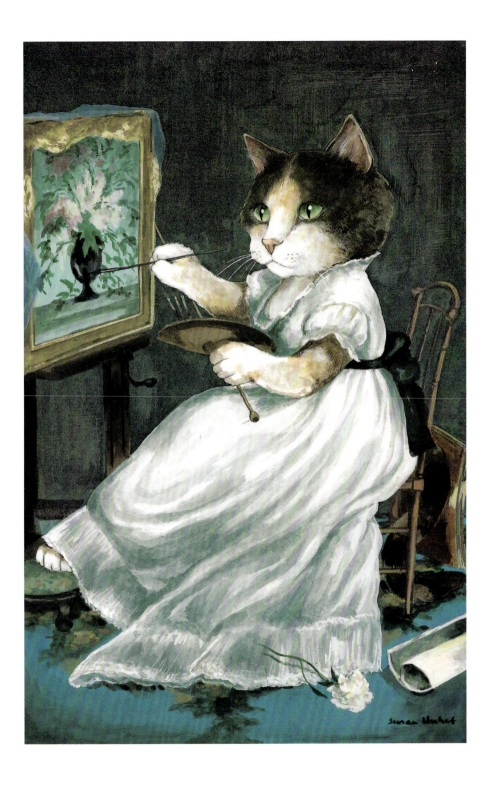

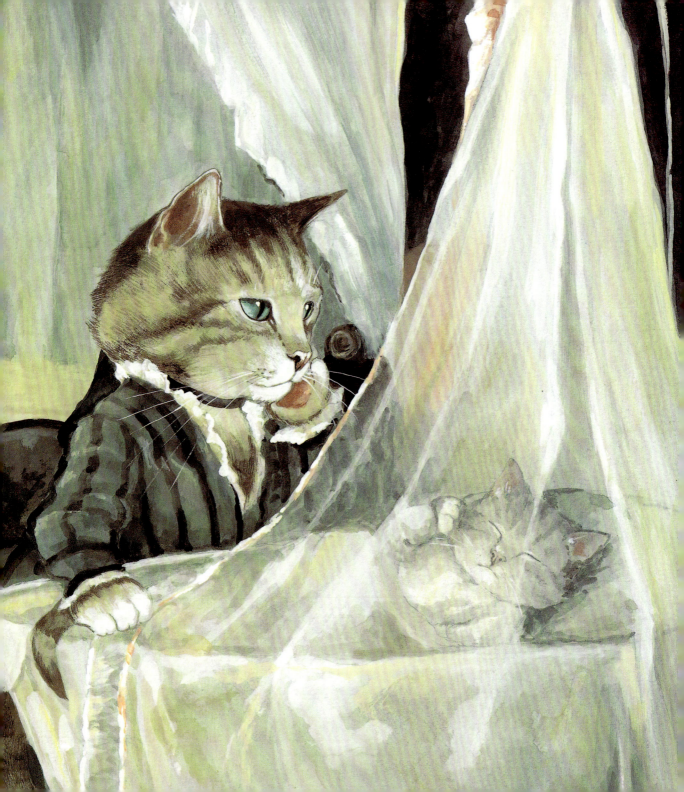

Berthe Morisot
The Cradle
1872

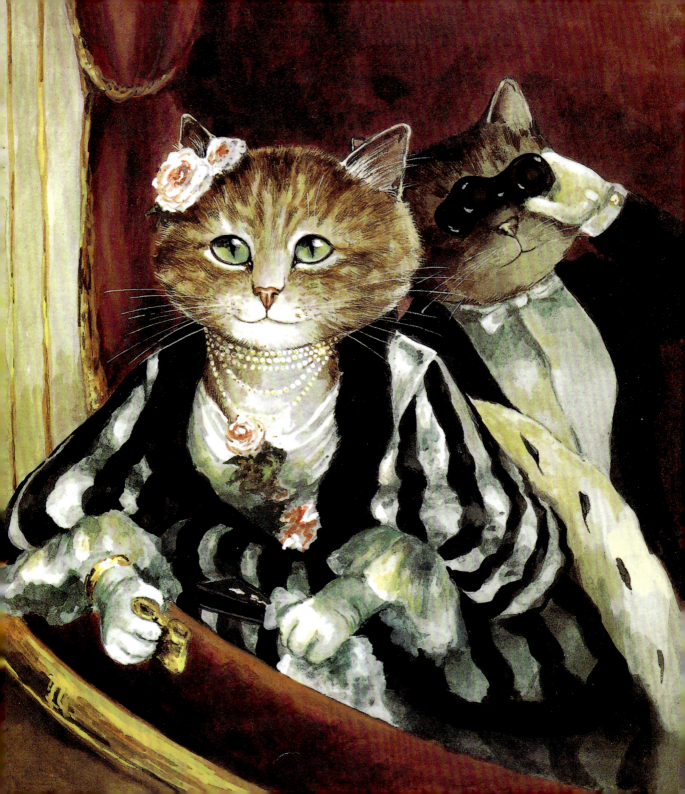

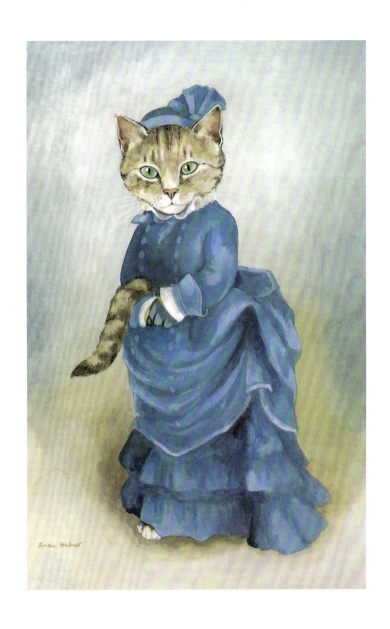

ABOVE Pierre-Auguste Renoir, *La Parisienne*, 1874

OPPOSITE Pierre-Auguste Renoir, *La Loge*, 1874

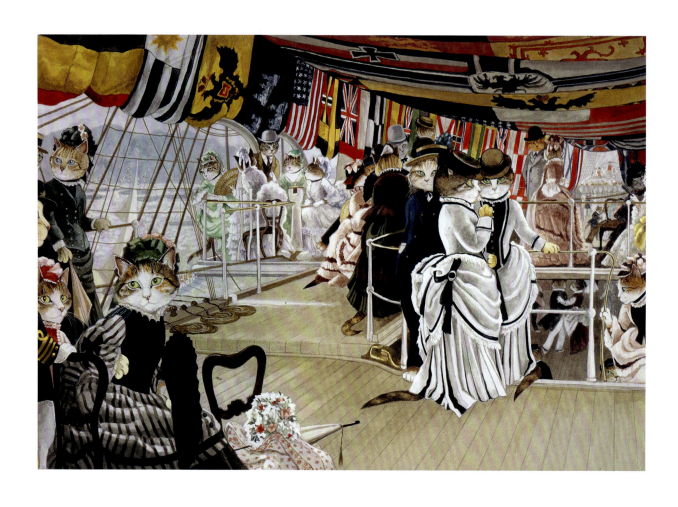

James Tissot, *Ball on Shipboard*, c. 1874

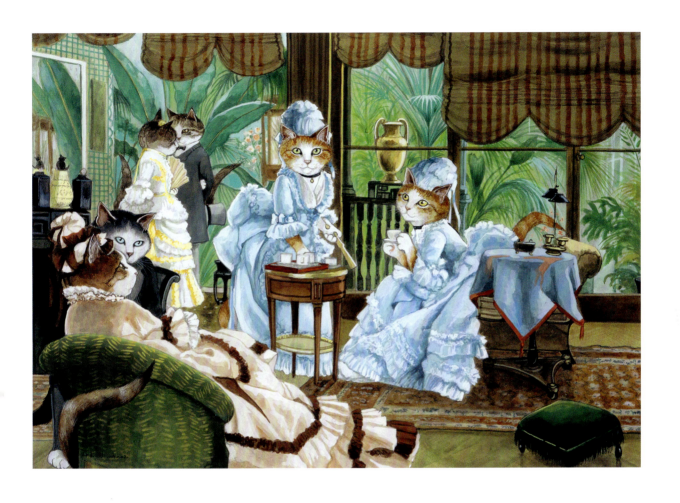

James Tissot, *In the Conservatory (The Rivals)*, 1875–8

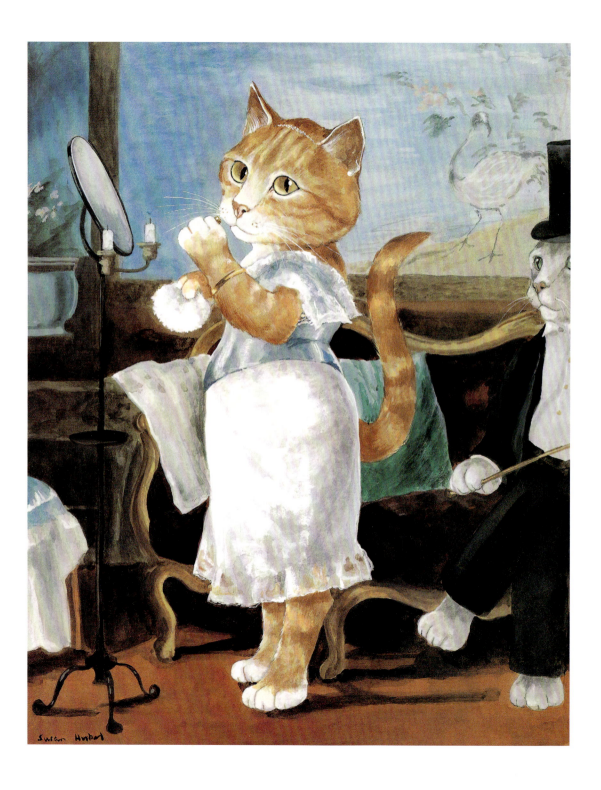

Édouard Manet
Nana
1877

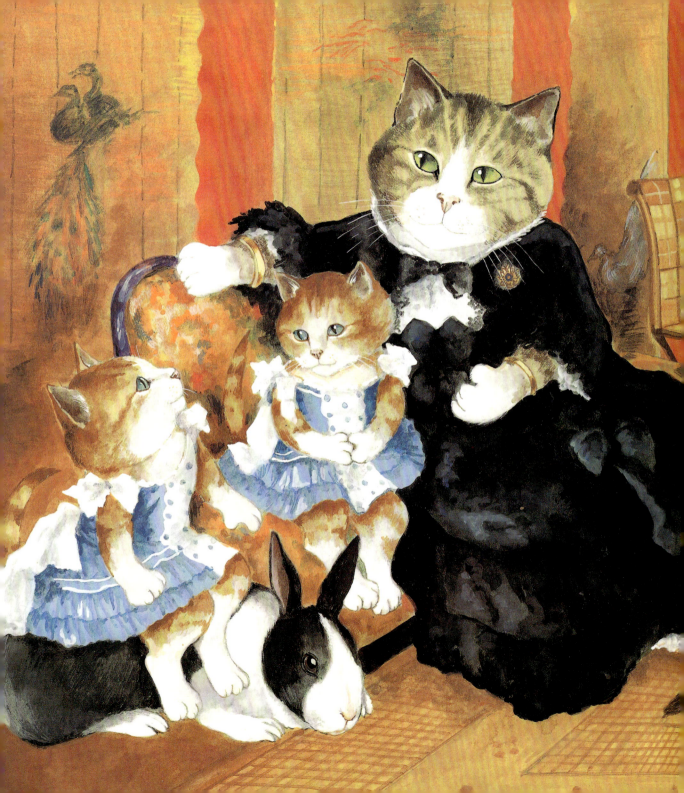

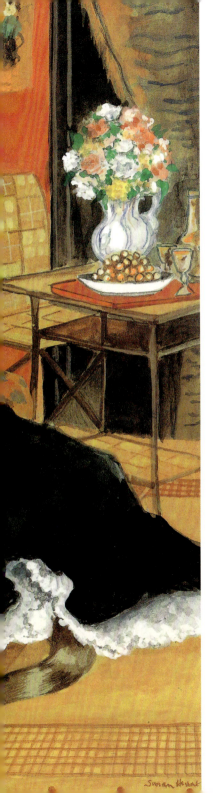

Pierre-Auguste Renoir
Madame Charpentier and her Children
1878

Edgar Degas
The Millinery Shop
1879–86

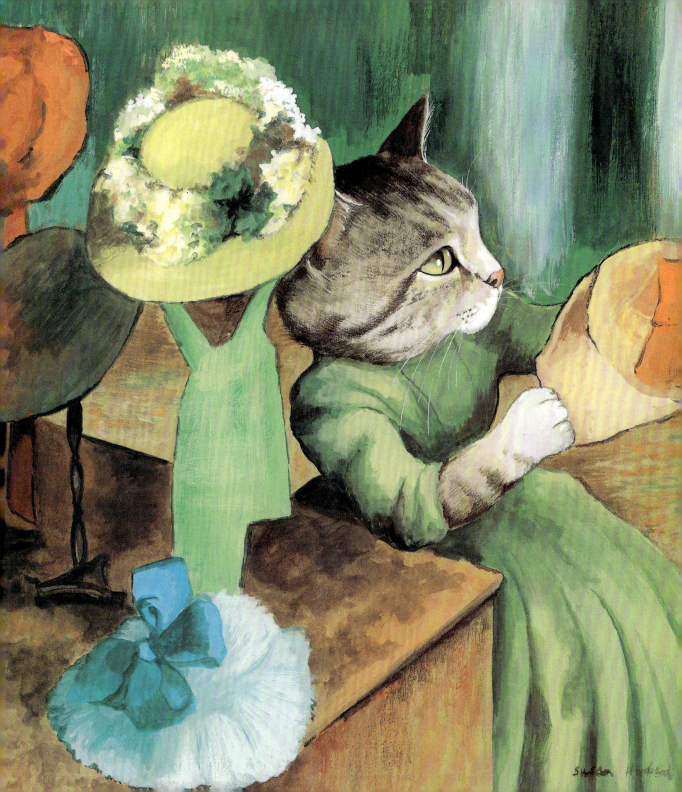

Mary Cassatt
The Loge
c. 1878–80

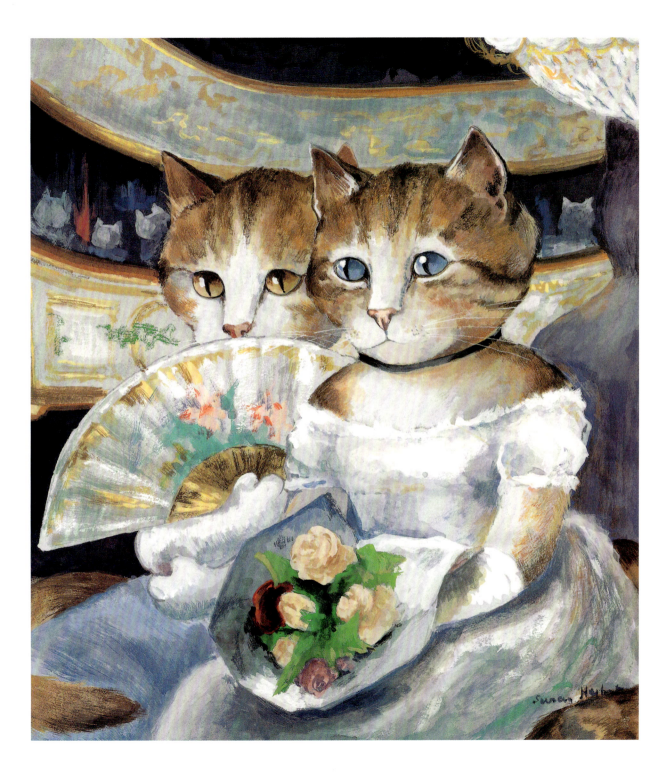

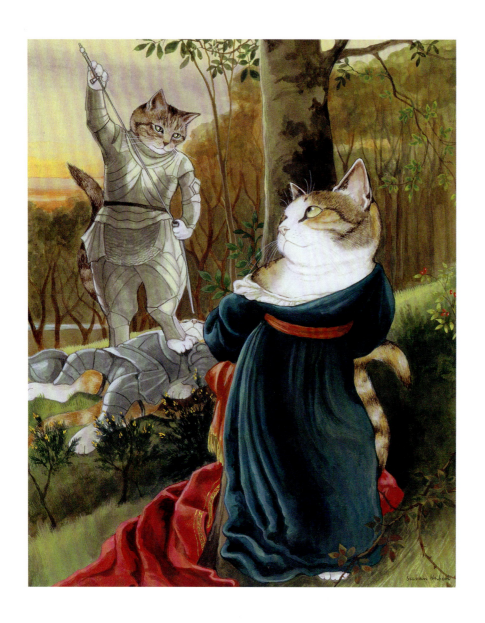

ABOVE Frank Dicksee, *Chivalry*, 1885

OPPOSITE Dante Gabriel Rossetti, *The Day Dream*, 1880

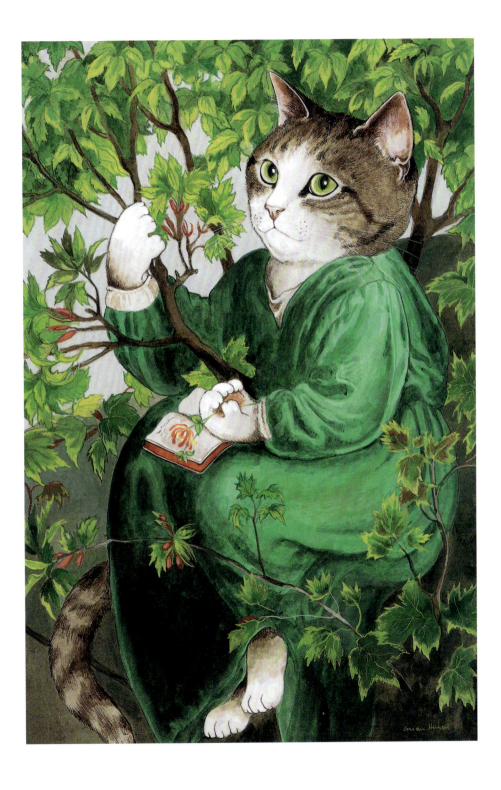

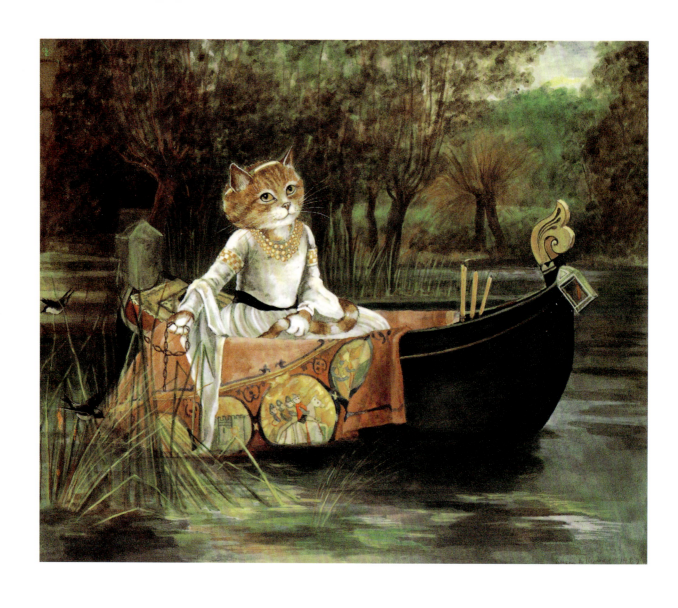

ABOVE John William Waterhouse, *The Lady of Shalott*, 1888

OPPOSITE John William Waterhouse, *Ophelia*, 1894

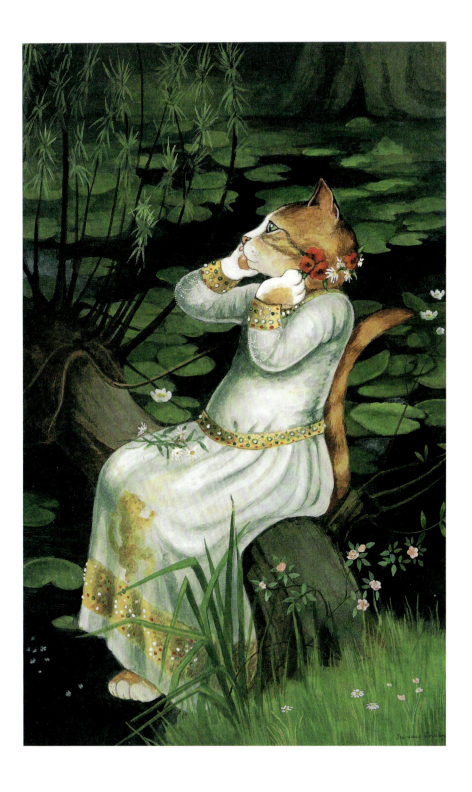

Vincent van Gogh
Self-Portrait
1889

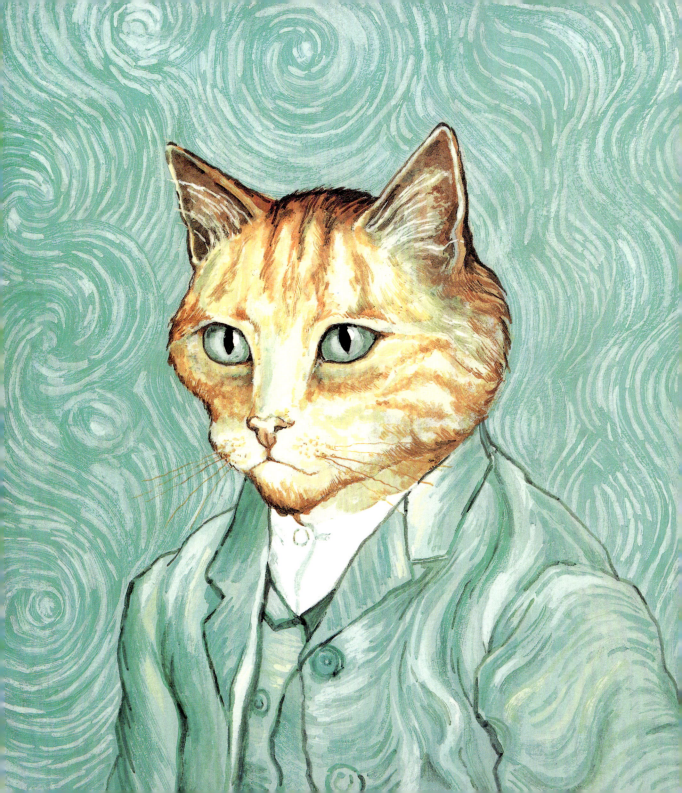

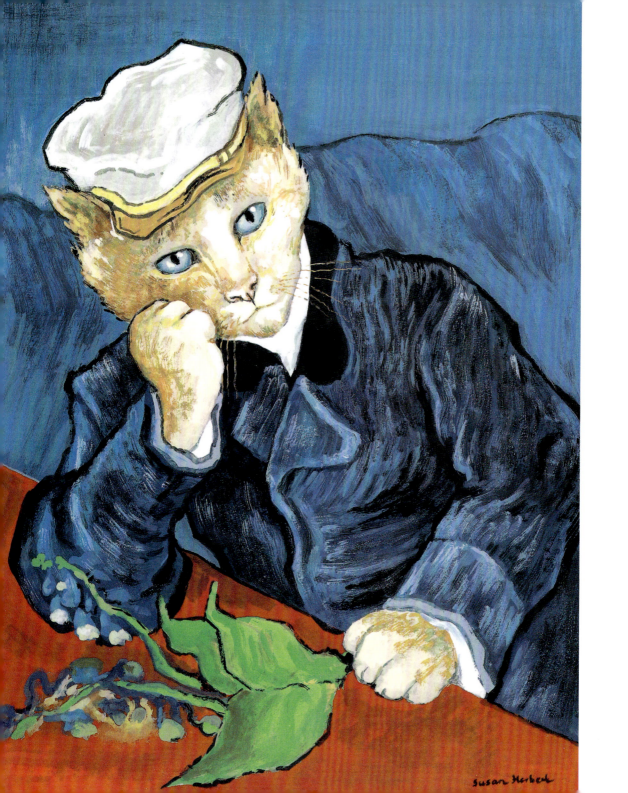

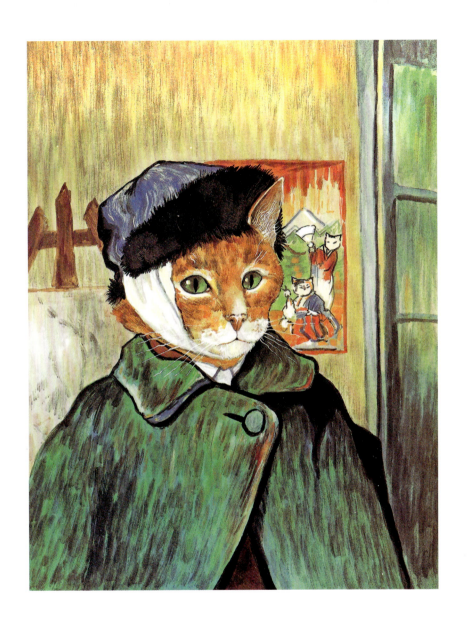

ABOVE Vincent van Gogh, *Self-Portrait with Bandaged Ear*, 1889

OPPOSITE Vincent van Gogh, *Portrait of Dr Gachet*, 1890

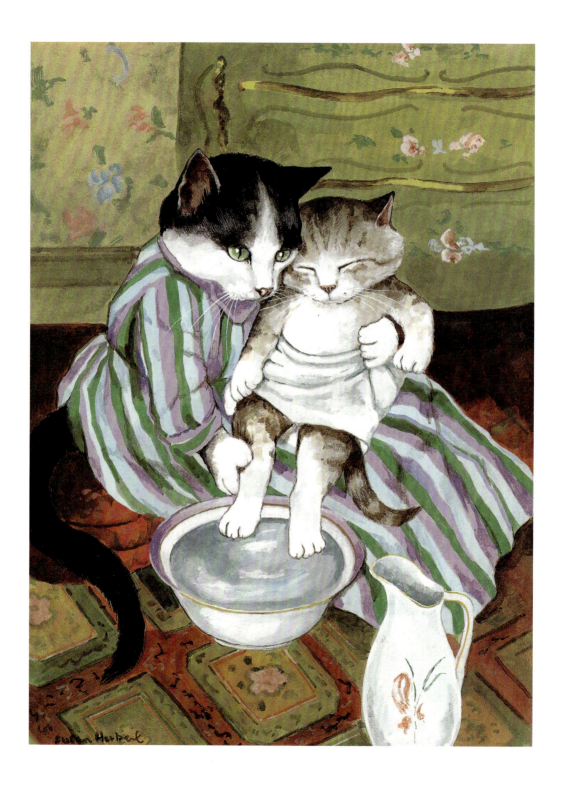

Mary Cassatt
The Child's Bath
1893

François Flameng
*Princess Zinaida Yusupova with her
Two Sons at Arkhangelskoe*
1894

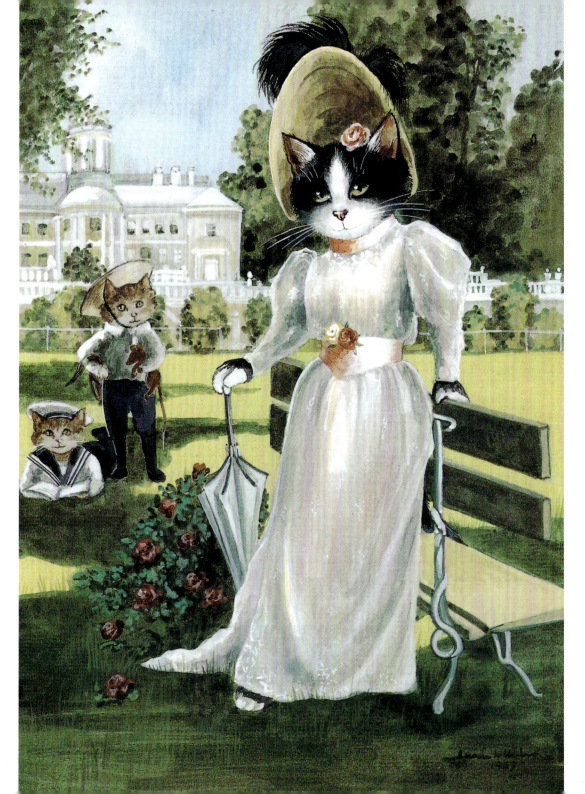